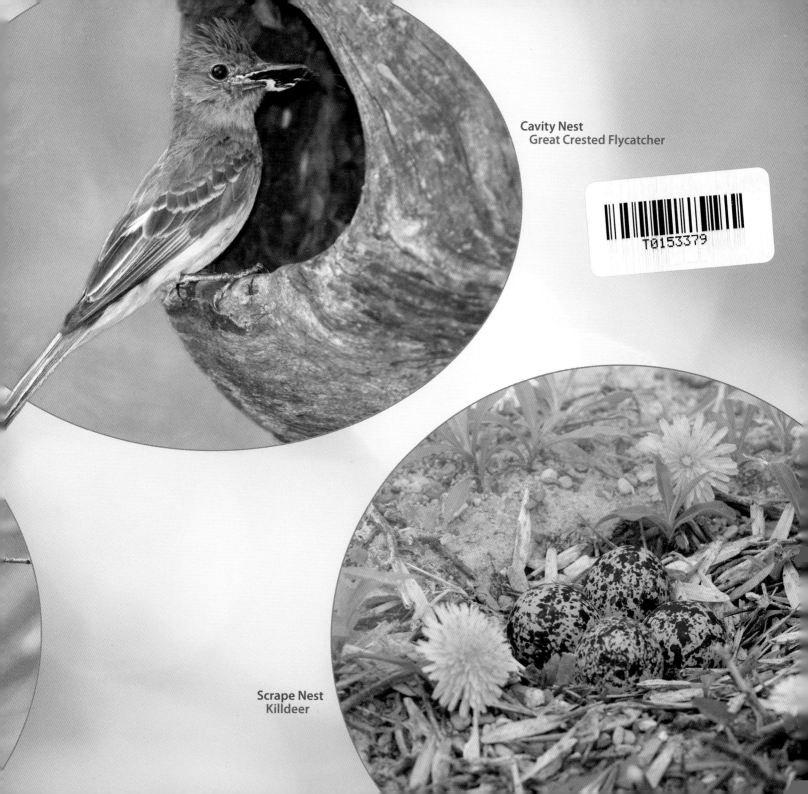

Cavity Nest
Great Crested Flycatcher

T0153379

Scrape Nest
Killdeer

Bird Nests

Amazingly ingenious and intricate

Stan Tekiela

Adventure Publications
Cambridge, Minnesota

Dedication

Dedicated to one of the giants in the world of naturalists/teachers, Kathlyn A. Heidel (1938–2014). Nearly 40 years ago she took me by the hand and showed me the details of the natural world. A true old-school naturalist whose knowledge of nature was unmatched. For all that you did for me, I will be ever grateful.

Acknowledgments

Many thanks to my good friends, colleagues and associates who help me in the pursuit of finding and photographing bird nests: Agnieszka Bacal, Debbie Cohn, Roberta Cvetnic, Susan Fagnant, Lee Greenly, Gregory Jahner, Terry Petro, Steve Weston, and the Bird Collection, Bell Museum of Natural History, University of Minnesota (St. Paul).

And thanks, once again, to my good friend Rick Bowers for his expert opinions and review of nest facts.

Edited by Sandy Livoti
Cover and book design by Lora Westberg
Cover photos by Stan Tekiela
All photos by Stan Tekiela except pg. 19 (nest with eggs) by Ron Green and pg. 75 (Thick-billed Murre) by Rick and Nora Bowers; pp. 124–125 from Shutterstock

10 9 8 7 6 5 4 3 2

Copyright 2015 by Stan Tekiela
Published by Adventure Publications
820 Cleveland Street South
Cambridge, Minnesota 55008
(800) 678-7006
www.adventurepublications.net
Printed in China
ISBN: 978-1-59193-468-4; eISBN: 978-1-59193-522-3

Nest and Egg Permits

Long ago, birds were indiscriminately killed for their feathers, eggs were collected by the basketful and nests were torn from trees, greatly diminishing many of the world's bird populations. U.S. laws were later passed to protect all of our native birds. Today, with very few exceptions, owning even a single bird nest, egg or feather requires special permits issued by federal, state and some local governments. Stan Tekiela has all of the required permits. Many of the nests and eggs in this book are the property of several different universities and nature centers.

A Note from Stan

The natural world is filled with marvels of engineering, and bird nests are great examples. Nests are utterly amazing, creative handiworks, yet ultimately simple. The parts of a nest may just be a collection of dead plants, but the ability of birds to gather, sort and work the materials into objects that safely hold the most fragile forms of life is nothing short of inspiring!

My fascination with birds reaches beyond photographing and identifying them in the field. From their unique feathers to their complex songs, mating rituals and wondrous nests and eggs, I am intrigued by their entire natural history. No other creature on earth, barring insects, exceeds the variety of birds and surpasses the sophistication of the nests they build.

I have spent the past 30 years traveling, studying and photographing birds and their nests and eggs, and I'm continually impressed by their capability to incubate eggs that result in live chicks. You see, for two decades I've been using electronic incubators to hatch chicken, duck and turkey eggs each spring, but warming eggs until they hatch is much more complicated than you might think! I am always humbled by the eggs that just refuse to hatch.

Nests provide protection and warmth, giving shelter from wild weather and offering baby birds security and a comfortable place to grow. We may take nests for granted since they are so common, but it's worth considering their diversity and function. I'm sure you'll agree that they are deserving of our appreciation—along with the fantastic birds that build them.

Table of Contents

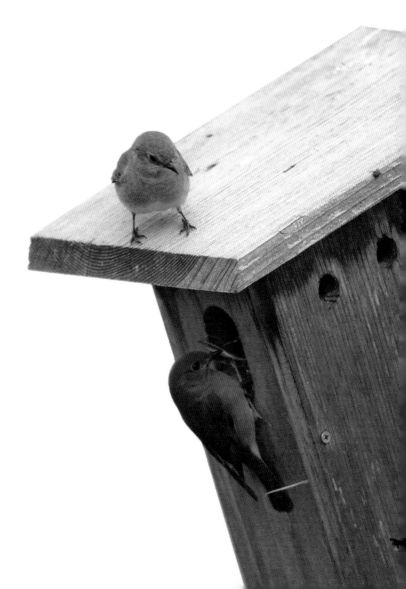

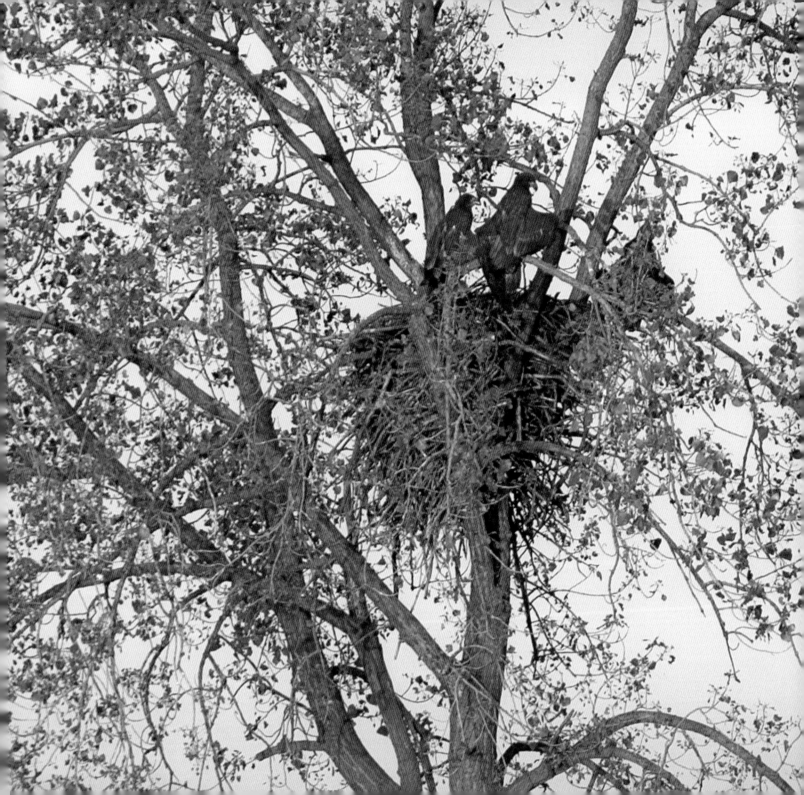

Nesting Ingenuity

The evolutionary history of nests is as complicated and diverse as the birds themselves. It is thought that the first nests were depressions or scrapes in the ground where eggs were laid. Plant debris was probably brought in later, starting the first constructed nests and resulting in the first platform nests. Eventually birds elevated their nests on dirt mounds or built them in shrubs and trees, raising them even higher. Meanwhile, other birds started digging into the earth, creating tunnels with chambers for egg laying.

The simple cup nest was a big leap forward in construction. Today this may be the most common nesting style. It is believed that the pendulous nest, a more complicated nest that hangs from branches, followed the cup nest. The cavity nest is another engineering marvel, where maximum protection for eggs and babies is assured. From scrape to cup to cavity, using nests to reproduce remains an excellent strategy for birds to survive the rigors of nature.

Bald Eagle

HOUSE RULES In general, bird nests are temporary places for egg laying and incubation. They also serve as containment structures for the young after they hatch and before they can fly. Depending on the species, bird nests function for as little as a week or upwards of several months. Nests are not typically used as permanent residences, like our homes.

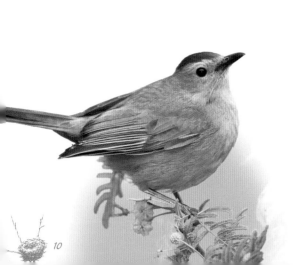

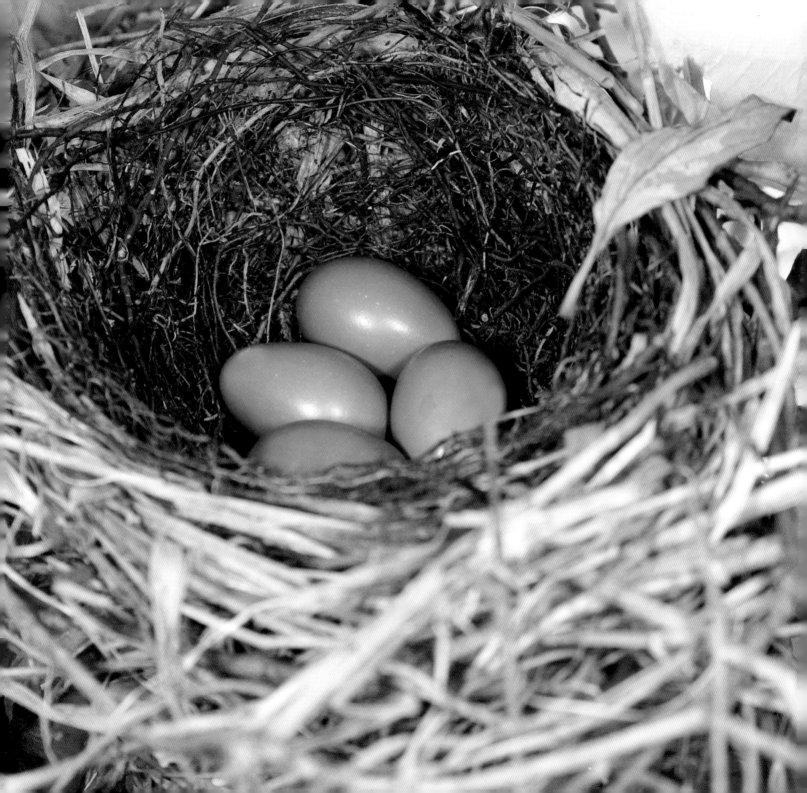

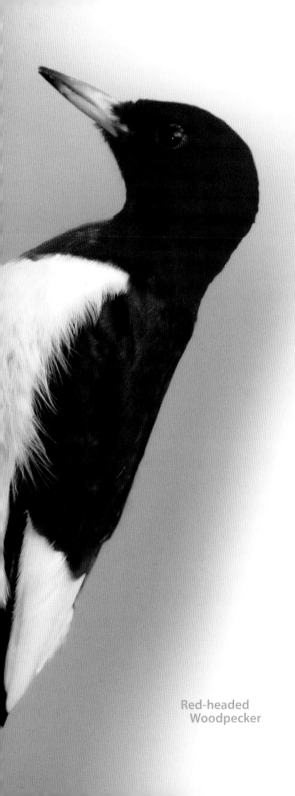

Dodging the house rules are Red-headed Woodpeckers. They use nest cavities not just for raising young, but also for sleeping. They store food in yet another tree cavity and defend all cavities from intruders year-round. Each one serves as a room of their home.

Most woodpeckers excavate one cavity and use it once to raise their young. After the babies leave the nest (fledge), the cavity is usually abandoned. This is advantageous for such birds as House Wrens, Eastern Bluebirds and Elf Owls, which use abandoned woodpecker holes to raise their young.

After the young leave their nests, they usually never use them again. The young of some species, however, will come back to their nests for up to a month or more. Ospreys and Purple Martins have this kind of extended nesting behavior. After a baby Osprey learns to fly, it often returns to the nest to rest and be fed by the parents. Purple Martins nest in colonies, and the whole gang hangs around the nesting chambers well after the young can fly. Purple Martin landlords are treated to the entire colony flying around, giving their chittering calls and catching bugs for most of the summer.

Red-headed
Woodpecker

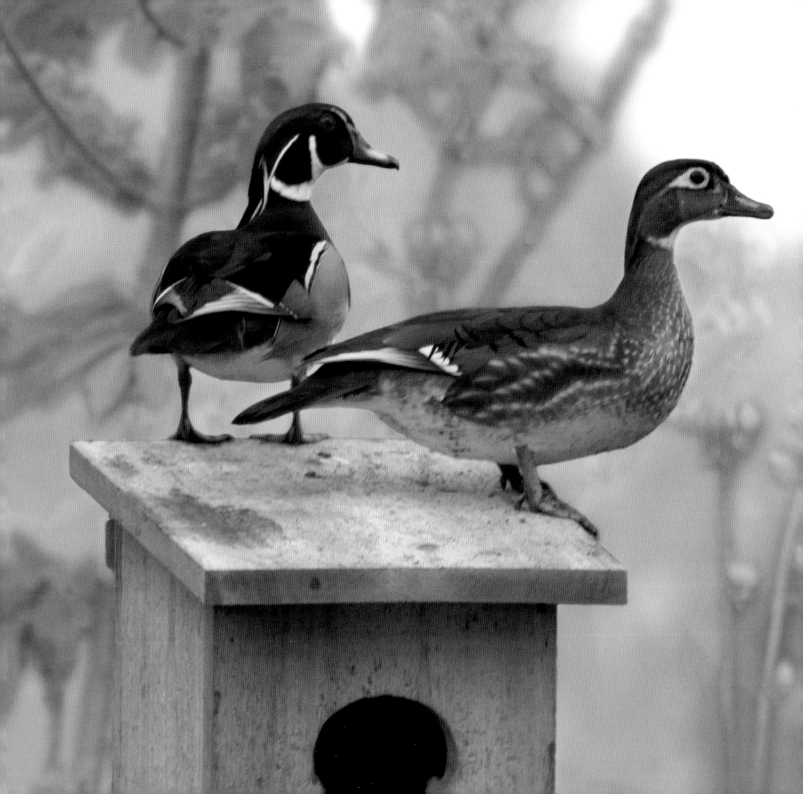

ELEMENTAL SHELTER Another important function of nests is to provide baby birds with shelter from the elements. Ovenbirds, for example, build nests with roofs to enclose and protect their young. Orioles weave nearly watertight, sock-like hanging nests that help keep their babies dry during rains and prevent them from falling out, even in the strongest of spring storms.

Wood Ducks nest in natural and man-made cavities. This shelter not only helps safeguard the mother while she incubates, but it also protects against rain, cold, sun and predators. Studies of cavity nests show that the air temperature in a tree cavity may be upwards of 10–12 degrees warmer during rainstorms on chilly spring nights than it is outside the nest.

Cliff Swallows nest in colonies and are famous for their gourd-shaped mud homes, complete with soft linings of grasses and feathers. These elaborate protective structures are often repaired and used for years.

Wood Duck

THE RIGHT SITE Choosing just the right place to nest is an important decision birds make. The main concern is predators. Nests must keep them from getting through cavity holes or other entrances, or be located within thick or thorny vegetation to thwart bird-eating predators such as Cooper's Hawks.

Using another tactic, hummingbirds often build near Cooper's Hawk nests to discourage other birds that would normally rob their eggs. Similarly, Arctic-nesting waterfowl, such as Snow Geese and Common Eiders, often build near Snowy Owl nests to deter Arctic Foxes and other land-based predators.

The location in sun or shade, in combination with a nest's thickness and nesting material, is vital to the uniform climate within the nest, or microclimate, that must be achieved. The microclimate is critical for the successful incubation of eggs and maintaining the health of growing chicks. While strong winds, heavy rains and other extremes can wreak havoc on a microclimate, increased nest thickness may reduce the energy requirement for egg incubation up to 15 percent! That's a big advantage for both the incubating parents and the generation that will soon hatch.

Mourning Dove

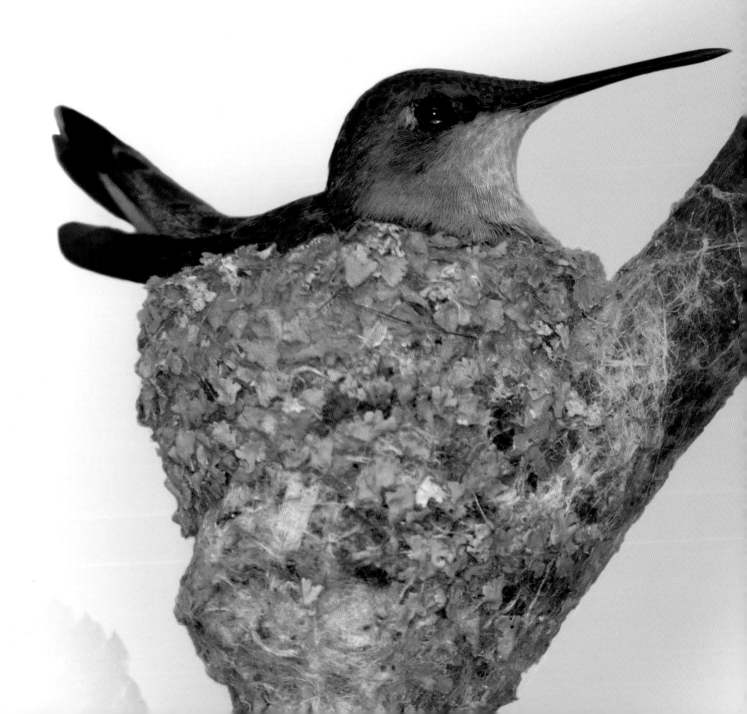

DIFFERENT SIZES Nest size is directly linked to the size of the maker. Hummingbirds are the smallest birds in North America and make the smallest nests. Measuring only half the size of a walnut, a hummingbird nest is built to accommodate just the incubating mother. Problem is, she almost always lays two eggs, so eventually there will be a couple of nearly adult-sized young in the nest. This is why she uses elastic spider silk during construction—it allows for expansion. As the chicks grow, so does the nest.

Typically, the smaller the bird, the smaller the twigs chosen for the nest. Tiny House Wrens collect many dozens of small twigs for their cup nests. American Crows collect larger twigs to make platform nests high in trees. Crows often reuse their nests for many years, adding twigs and rearranging the nesting material each season.

Ruby-throated
Hummingbird

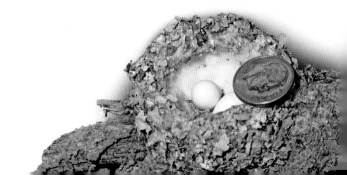

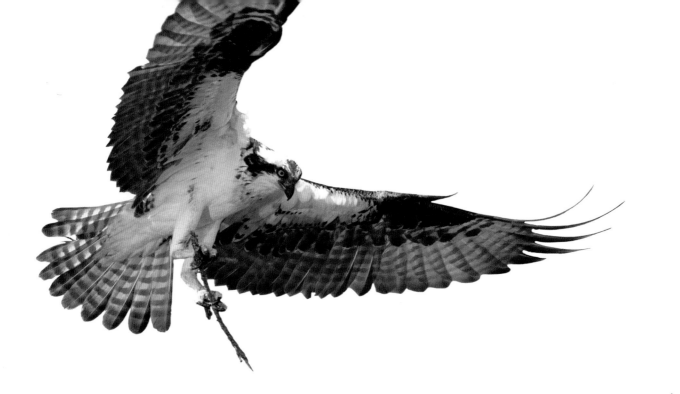

Common Ravens make medium-sized nests with small to medium twigs. Red-shouldered Hawks, which are midsized hawks, use medium twigs and sticks to build nests up to 2 feet across and 1 foot thick.

Ospreys and other large raptors carry big sticks and branches up to several inches in diameter and up to 4 feet long. Eagles collect the largest materials and build the largest nests. Bald Eagle nests are enormous, with some over 10 feet wide, 20 feet tall and weighing more than a ton!

Osprey

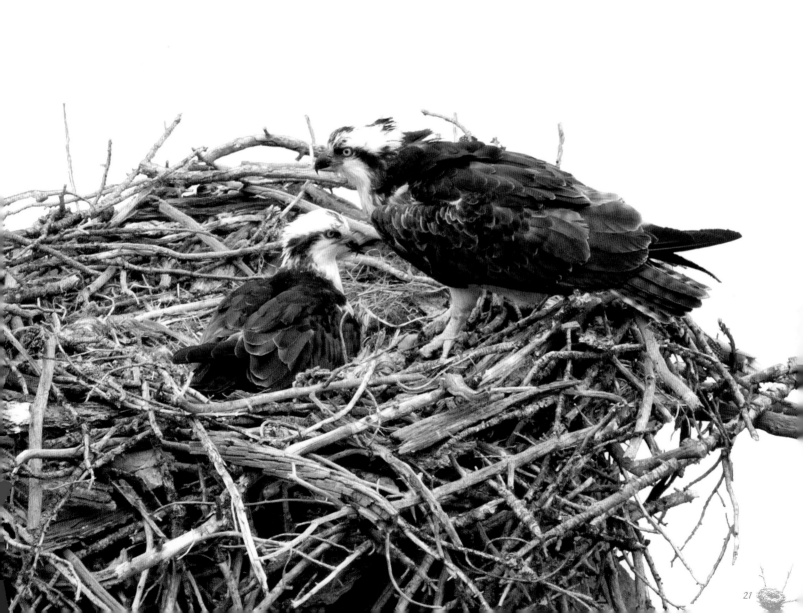

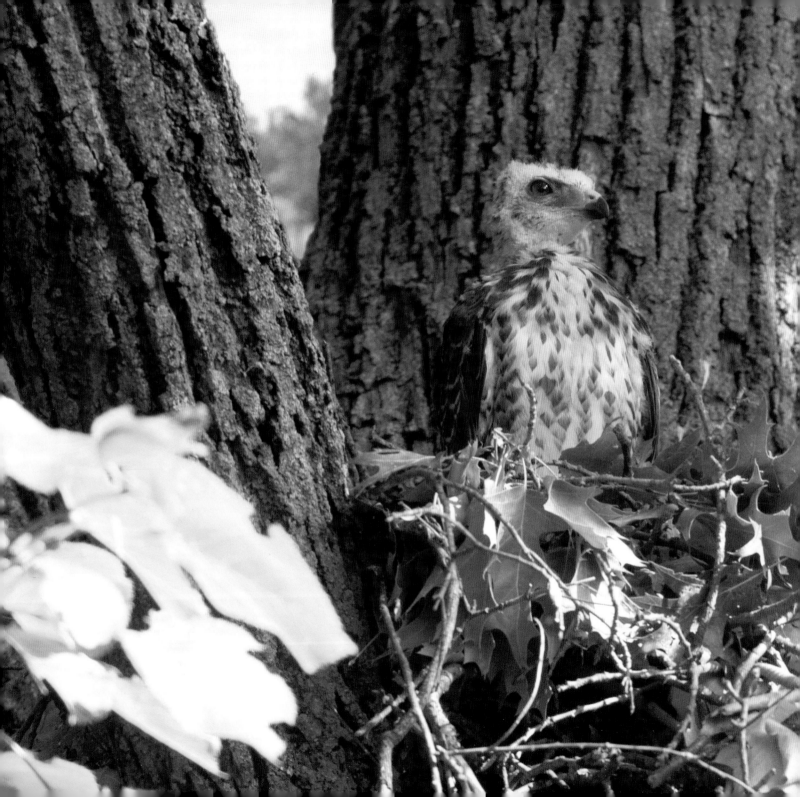

Materials Mix & Match

NESTING MATERIALS usually consist of the most abundant natural substance in the area. However, most birds have preferences and collect a specific type, such as tiny twigs or dried grasses, until construction of the nest is complete. Other birds build with a variety of plant materials, such as twigs, grasses, leaves and bark. Materials are often meticulously chosen for their natural properties, which may permit easy weaving, offer camouflage or repel insects. The materials of choice for many bird species are twigs, sticks and branches.

Broad-winged
Hawk

SOFT AND EASY Most of our songbirds use grasses, leaves, green stems, mosses and other soft plant materials to build their nests. These kinds of materials are lightweight and easy to carry to the nest site. They are also easier for birds with small bills to manipulate and weave. Nests made with soft materials last just long enough to raise the young. Considering the billions of birds in the world, it's good that these nests break down quickly. If they didn't, our trees would be littered with old nests for years.

Black-capped Chickadees build in cavities and line the interior with lots of fur—some even overflow with it! Fur helps keep the eggs and young warmed while the parents are temporarily away from the nest.

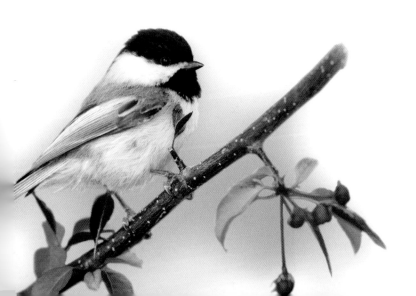

Black-capped
Chickadee

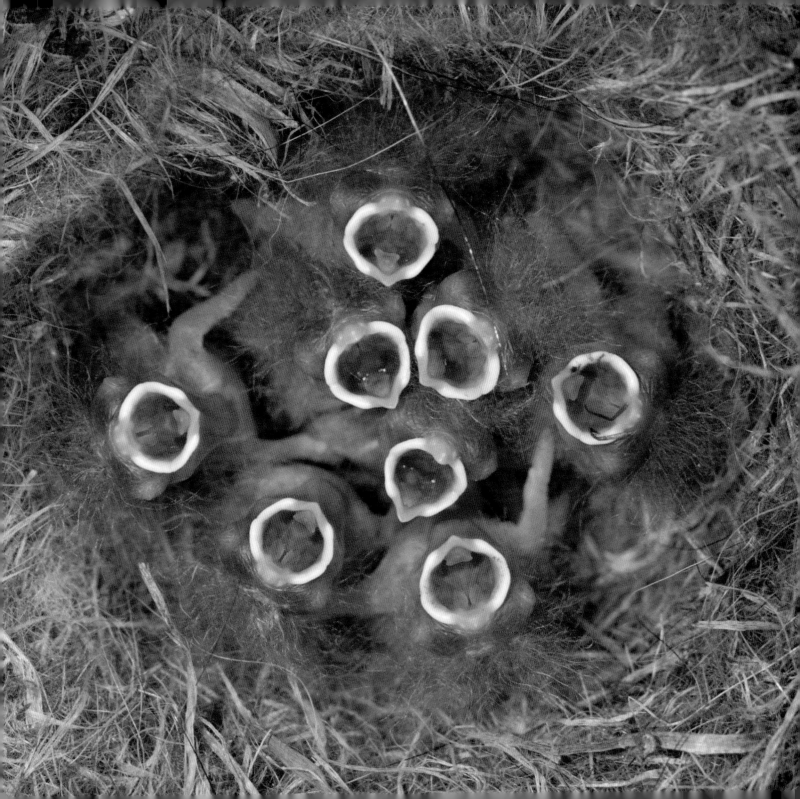

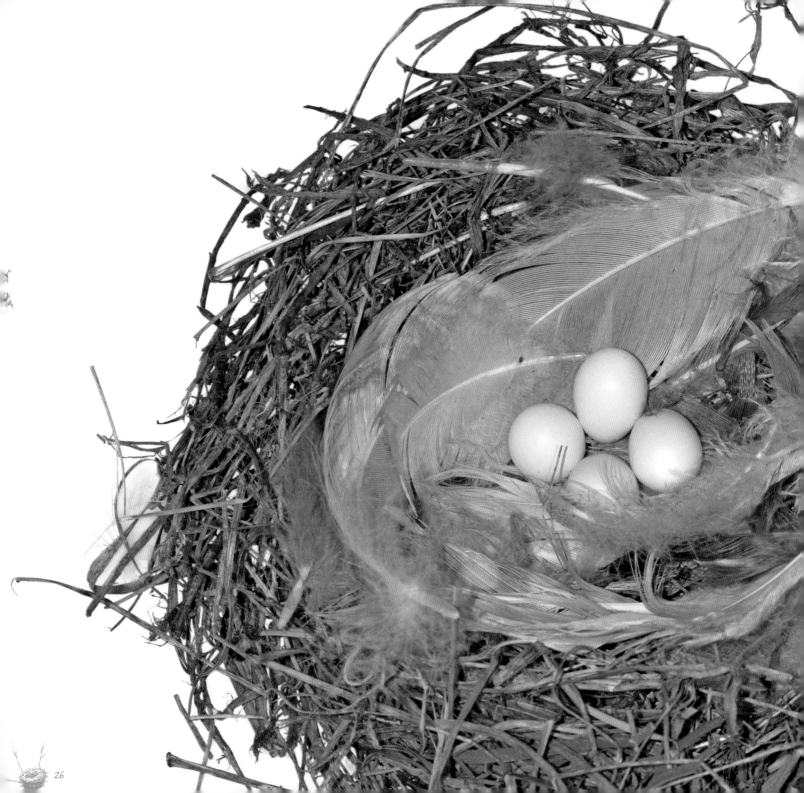

Tree Swallows are known for lining their cup nests with feathers molted by other birds. Studies show that Tree Swallows with abundantly feathered linings are more successful at raising young than others using fewer feathers. Barn Swallows and other species use small amounts of dried grasses to line their nests. House Wrens line their nest chambers with soft and comfortable plant materials, oftentimes fine rootlets and blades of dried grass.

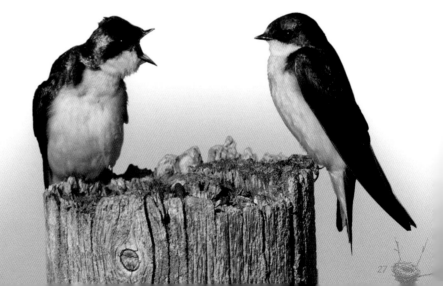

Tree Swallow

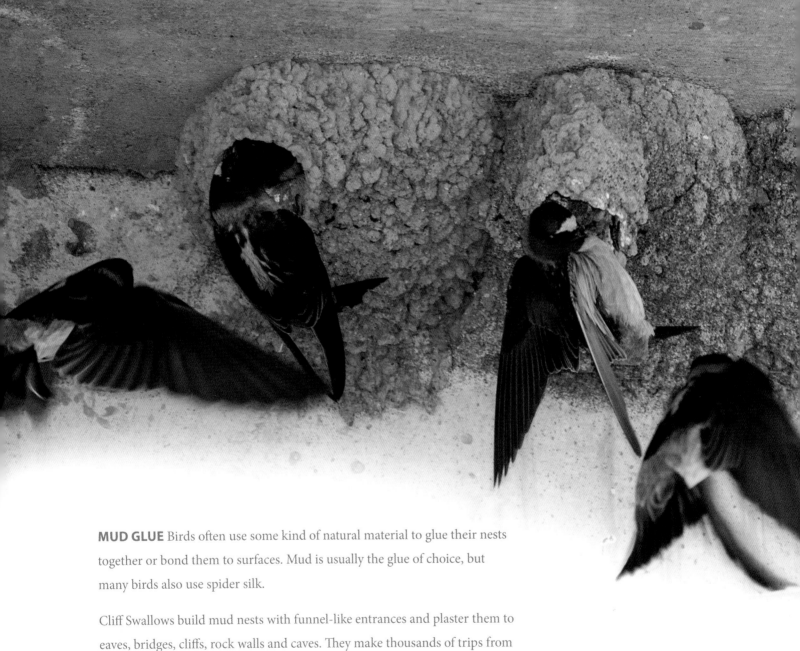

MUD GLUE Birds often use some kind of natural material to glue their nests together or bond them to surfaces. Mud is usually the glue of choice, but many birds also use spider silk.

Cliff Swallows build mud nests with funnel-like entrances and plaster them to eaves, bridges, cliffs, rock walls and caves. They make thousands of trips from the mud hole to the nest, carrying mud pellets in their beaks. Each nest takes upwards of two weeks to build.

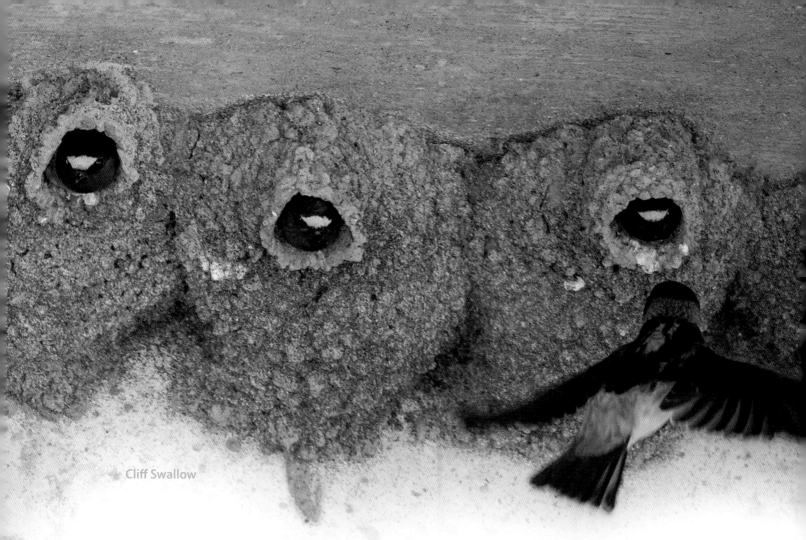

Cliff Swallow

EXTERIOR DECORATING So many species do more than just build a nest. Once the major construction is finished, birds also decorate the exterior, plastering lichens to the sides and gluing them in place with sticky spiderwebs. Gnatcatchers and hummingbirds are great at this type of handiwork. Lichens help to camouflage, but they also may help to keep moisture in the nest, which is critical during the incubation process. And like a blanket on a bed, a lichen layer on the outside of a nest probably helps keep the interior of the nest warm.

WHERE'S THE BUG SPRAY? Interestingly, many birds add other special materials to the nest. Many species of raptors, starlings and swallows add green plant materials after their nests are fully constructed. These make the nests look fancy, but the greenery isn't for decoration, as once thought. Recent research shows that the additional green plants are carefully selected for their chemical content, which helps repel or kill insects, thus introducing a pesticide effect.

European Starlings, for example, bring in yarrow, a herb that contains insect-repelling chemicals. Since nestlings can be captive hosts for many insects, adding special plants is a natural way to keep both the babies and the nest free of bugs.

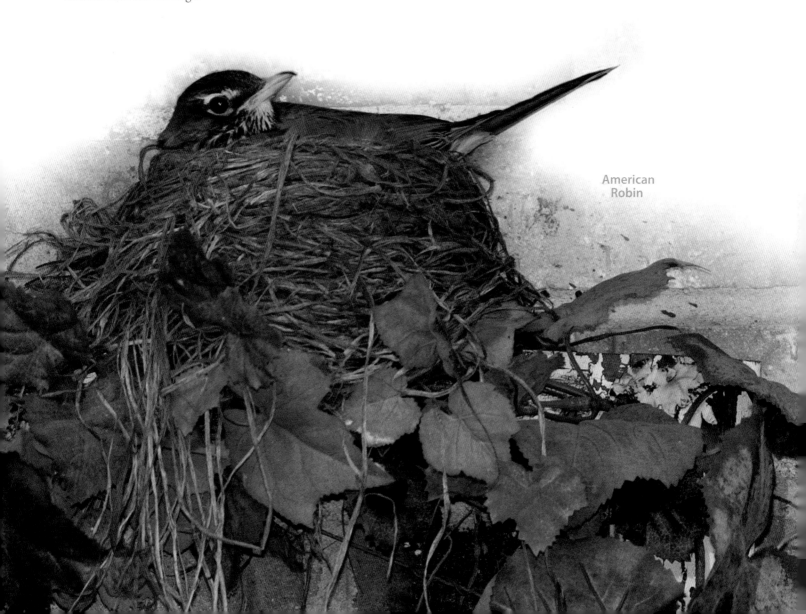

American
Robin

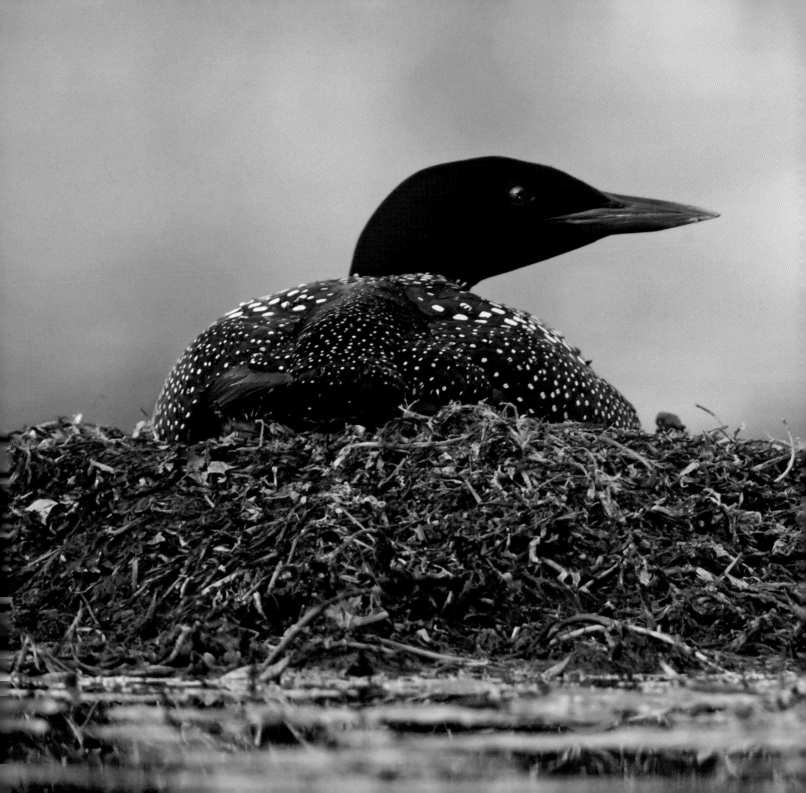

Nest Varieties & Designs

THE VARIETY AND DESIGN OF NESTS developed over millions of years from simple scrapes in the dirt to sophisticated dome-shaped adobes. There has been plenty of time to modify nesting behavior, but birds continued to use nests and produce eggs. This winning combination enabled them to stand the test of time and perpetuate their species. Natural selection served as the force behind the variety of nests and still assists in bird survival. Without the sustained abilities to successfully build diverse nests, birds could not continue to flourish today.

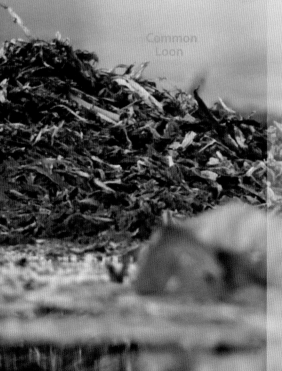

Common Loon

CUP NEST Cup nests are often made with a variety of coarse materials ranging from dried grasses to twigs, mud and saliva. Soft plant materials line the inside of the cup.

Eastern Kingbirds weave open cup nests with small twigs, dried stems and bark strips, and line them with cattail and cottonwood down. Black-capped Chickadees build cup nests in tree cavities. Inside cavities, adhesive and weaving aren't needed to hold the nests in place. Chimney Swifts use finer materials and glue them together with their spit. That's right—they produce a saliva that dries to a cement-like consistency and actually glues the nest to a vertical surface! As the name implies, Chimney Swifts nest in chimneys. Prior to artificial structures, the birds nested in hollow trees.

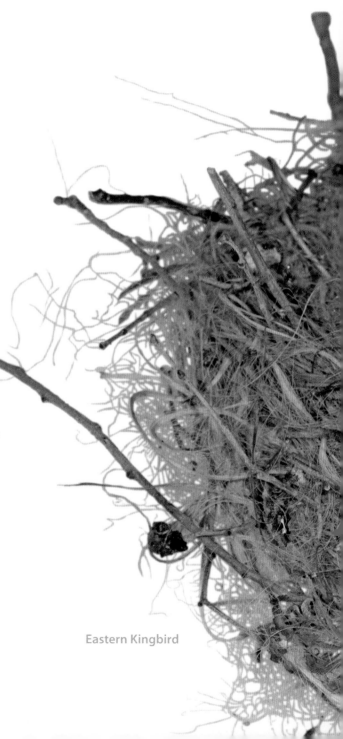

Eastern Kingbird

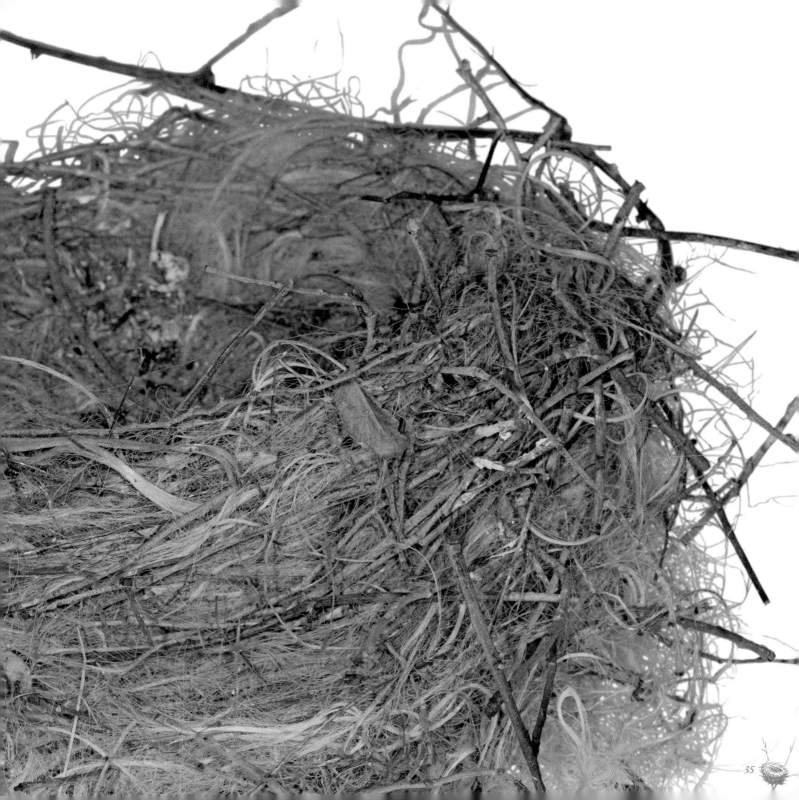

35

PLATFORM NEST A basic platform nest consists of a pile of nesting material with a shallow depression in the center. Mourning Doves make flimsy, twiggy platform nests that seem to fall apart in the breeze. Ospreys use sizable branches to build their bulky nests. These large raptors leave many openings in the base, and sometimes an egg slips through and falls to the ground far below.

Red-necked Grebes and many other water birds use floating platform nests. These flat structures float with the water level, protecting the precious eggs within.

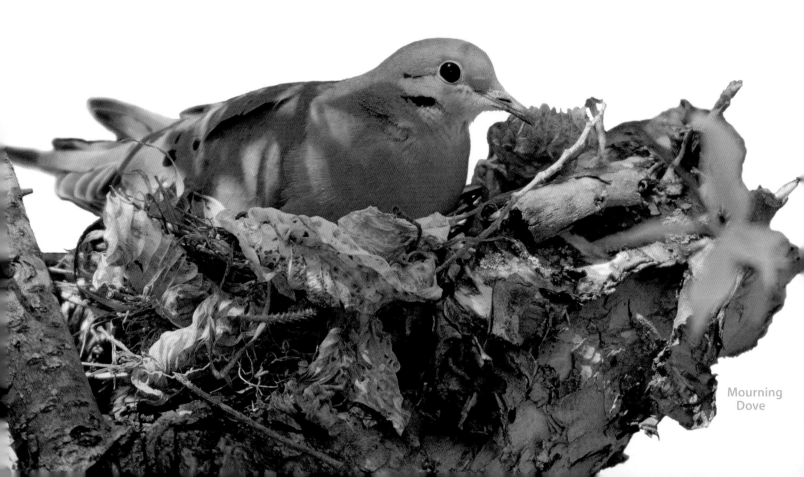

Mourning
Dove

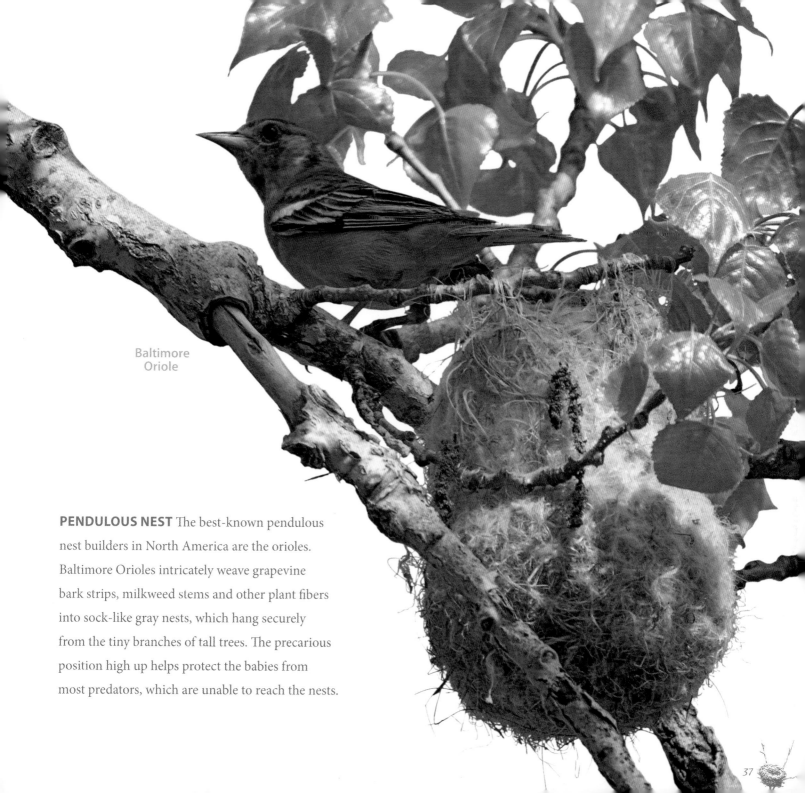

Baltimore
Oriole

PENDULOUS NEST The best-known pendulous
nest builders in North America are the orioles.
Baltimore Orioles intricately weave grapevine
bark strips, milkweed stems and other plant fibers
into sock-like gray nests, which hang securely
from the tiny branches of tall trees. The precarious
position high up helps protect the babies from
most predators, which are unable to reach the nests.

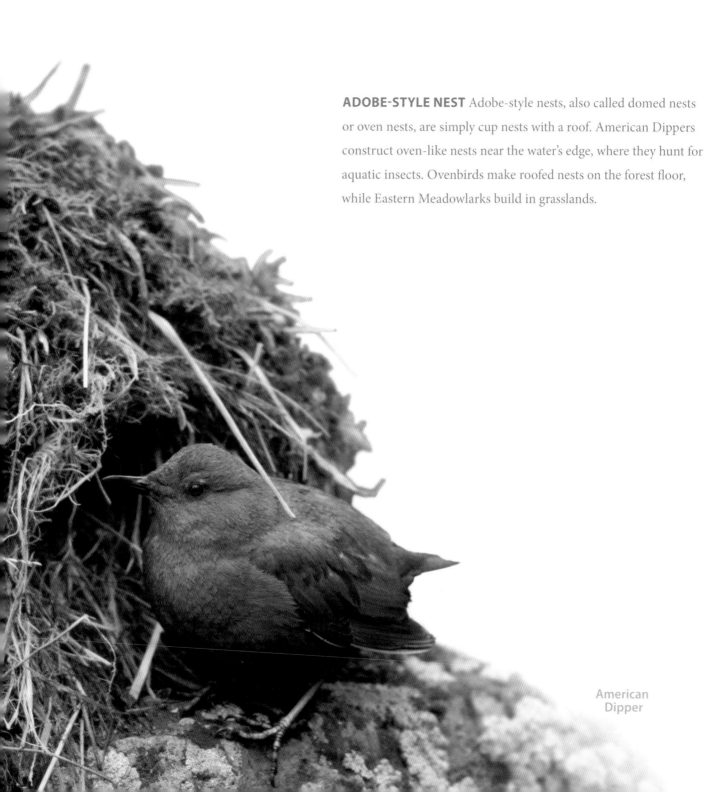

ADOBE-STYLE NEST Adobe-style nests, also called domed nests or oven nests, are simply cup nests with a roof. American Dippers construct oven-like nests near the water's edge, where they hunt for aquatic insects. Ovenbirds make roofed nests on the forest floor, while Eastern Meadowlarks build in grasslands.

American Dipper

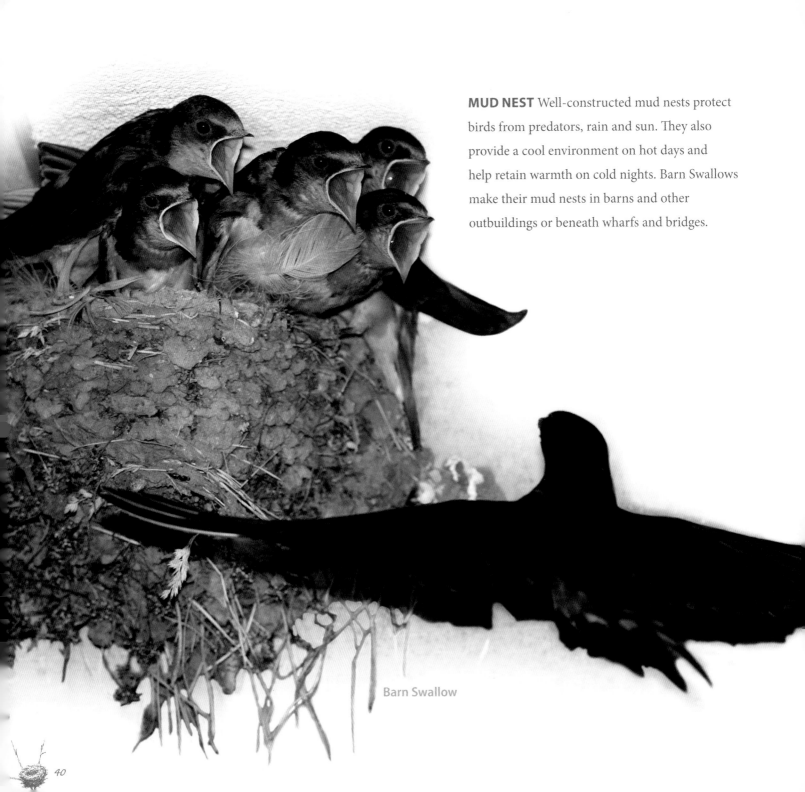

MUD NEST Well-constructed mud nests protect birds from predators, rain and sun. They also provide a cool environment on hot days and help retain warmth on cold nights. Barn Swallows make their mud nests in barns and other outbuildings or beneath wharfs and bridges.

Barn Swallow

CAVITY NEST This is one of the most sheltered nests. Woodpeckers take the lead in excavating cavities in dead trees, followed by chickadees and nuthatches. Woodpecker cavities usually have a wide bottom and a small entrance hole. Eggs are laid on the cushion of woodchips created during excavation.

Belted Kingfishers, Bank Swallows and other birds dig burrows in dirt hillsides, ending in a chamber. The cavities are often just a foot deep, but kingfishers dig impressive tunnels up to 6–10 feet long! To keep water out, the birds dig their nesting chamber higher than the entrance hole. Only scant nesting material is brought into the chamber, where the eggs are laid.

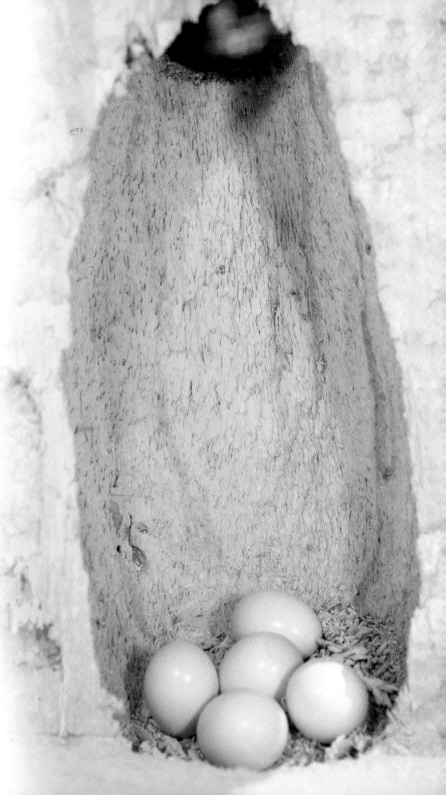

Downy
Woodpecker

SCRAPE NEST The scrape nest hardly seems like much of a nest. Shorebirds and many cliff-dwelling birds of prey just scratch the dirt in open areas and deposit their eggs there. Scrapes have limitations—mainly, eggs rolling away and easy access by predators. Although egg color and speckling help camouflage the nest site, a diversion may be needed when a predator comes near. A Killdeer, for example, will fake a broken wing to draw the danger away.

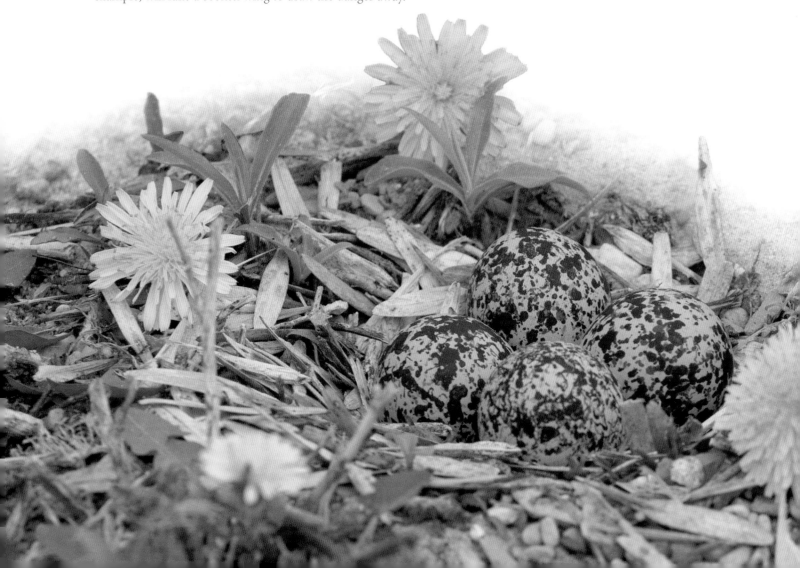

GROUND NEST Many shorebirds, such as Spotted Sandpipers, utilize ground nests. These are usually constructed with materials from the immediate vicinity around a shallow scrape in the ground, which contains the eggs. Because ground nests are vulnerable to predators, most ground nesters choose sites within heavy vegetation for cover and concealment.

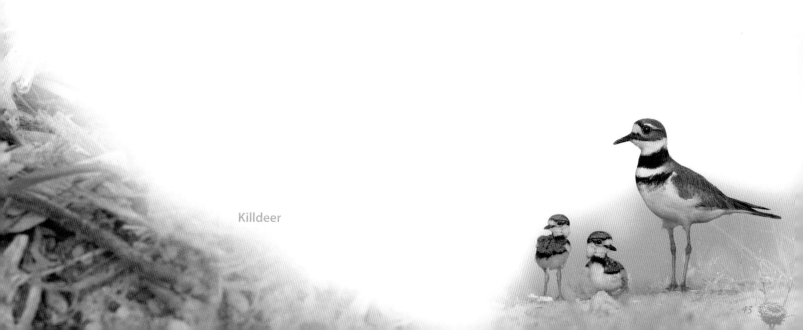

Killdeer

MOUND NEST A mound nest consists of a substantial pile of plant material with a slight depression in the center. Common Loons gather wet vegetation from around their nest sites to construct their mound nests, which function like raised platform nests. There isn't much craftsmanship in these nests, but the end result produces safe nests that keep the eggs up and out of the water.

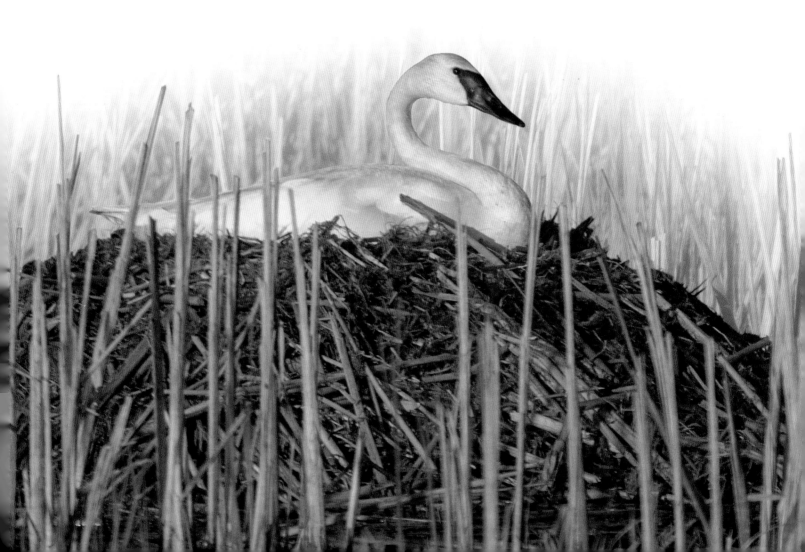

NEST BOX Nature has provided birds with plenty of materials and nesting locations for millions of years. However, man changed the environment so much that some species struggled to find adequate materials or suitable sites. Cavity-nesting Eastern Bluebirds, House Wrens and Purple Martins declined due to the lack of nesting opportunities. To increase the populations, concerned individuals and groups intervened, putting up nest boxes for these species, with much success.

Wood Ducks, Common Goldeneyes and Hooded Mergansers are some of our water birds that require nest cavities. They normally would use natural cavities in trees, but the clear-cutting of forests and the removal of dead and dying trees have led to a sharp decrease in nesting locations. Wooden boxes with large openings are a good alternative for these birds.

Trumpeter
Swan

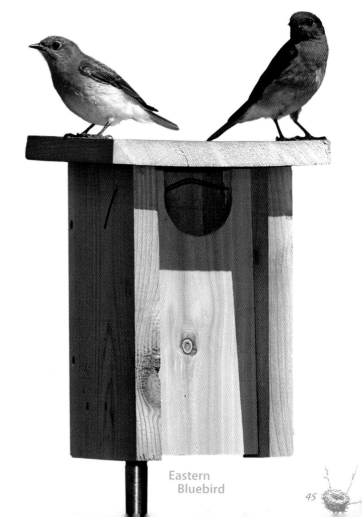

Eastern
Bluebird

45

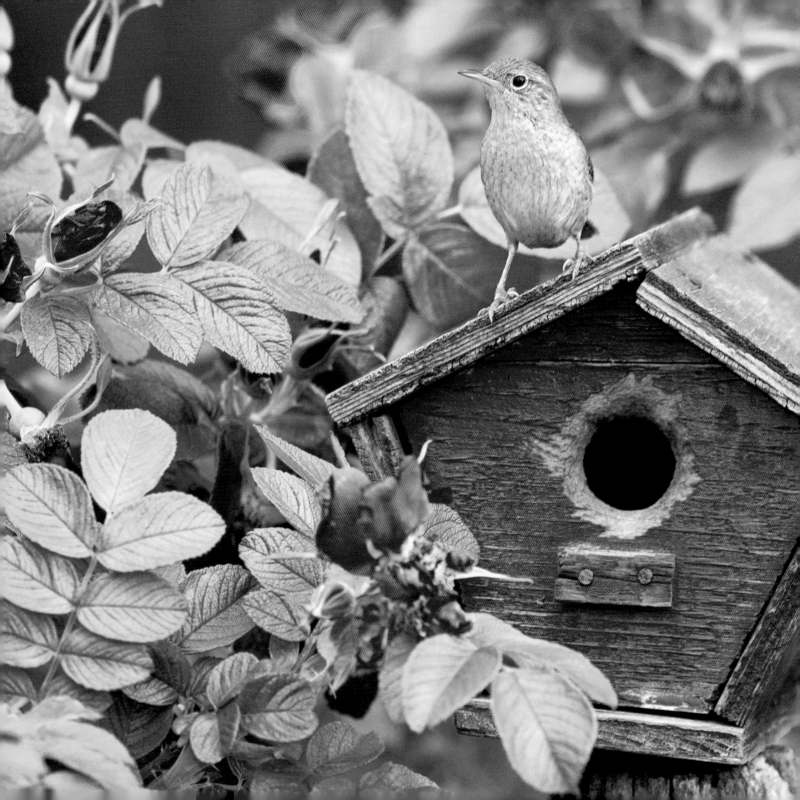

Curious Nesting Behaviors

NEST BUILDING IS A STRANGE BEHAVIOR for an animal that doesn't have hands. You might think that such intricate craftsmanship would require skilled, nimble fingers. Instead, a bird cleverly uses its bill, feet and body to gather, transport and manipulate the nesting material into a cohesive nest. Some species take the wonders of nest construction a few steps further, exhibiting unusual behaviors that can help you identify the builders.

House Wren

EXTRAS, JUST IN CASE Curiously, raptors and wrens construct extra nests in their territories. These provide for rapid re-nesting if the first nest is lost to bad weather or destroyed by predators. Extra nests built by a male may also help him attract a second female, maximizing his reproductive possibilities. Male House Wrens are known to do this. The male constructs several nests in cavities within his territory and allows his mate to choose the one she wants. After she moves in, he tries attracting a second female to his other nests in an effort to father two broods in one season.

Sometimes a pair of raptors start building a second nest near the first, occasionally in the same tree or within sight of the original nest. If they were unsuccessful at raising young in previous years, they may be trying again by building a different nest nearby. Another possibility is that a new mate usurped one of the resident raptors and is building a nest for its new family.

Bald Eagle

48

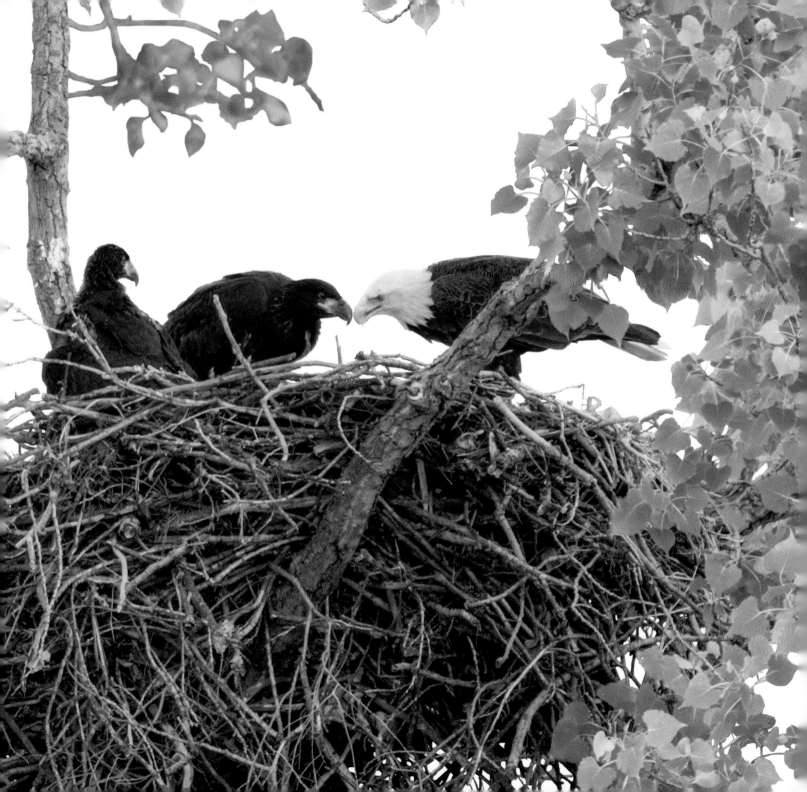

EGG DUMPING Nest sharing, an uncommon behavior also known as egg dumping, occurs in Wood Ducks and Hooded Mergansers. Females nest in natural or man-made cavities with no added nesting material. They pluck down feathers from their chests and bellies to line the nesting chamber after starting to lay eggs. Like all birds, a Wood Duck female can lay only one egg per day, and because she waits until all eggs are laid before starting to incubate them, the chamber is vacant when she's not laying an egg. Other females that haven't found their own nest cavities often "dump" their eggs into these temporarily vacant nests, greatly adding to the number of eggs. Thus, it is not unusual for a female Wood Duck to incubate upwards of 30 eggs in a nest. In fact, I have personally had boxes with over 25 eggs! Not all hatch, but most do. Sometimes a second female will also try to incubate the eggs, resulting in two females in the cavity sitting side by side on the eggs.

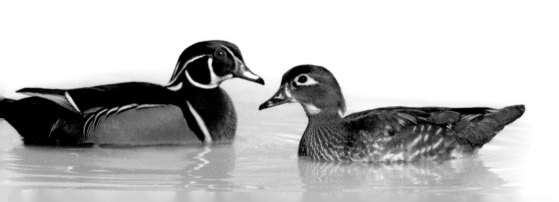

Wood Duck

It's common for merganser females to lay their eggs in other merganser nests, as well as in Wood Duck nests. In the latter case, baby Hoodies hatch right alongside the Wood Duck hatchlings and become part of that family.

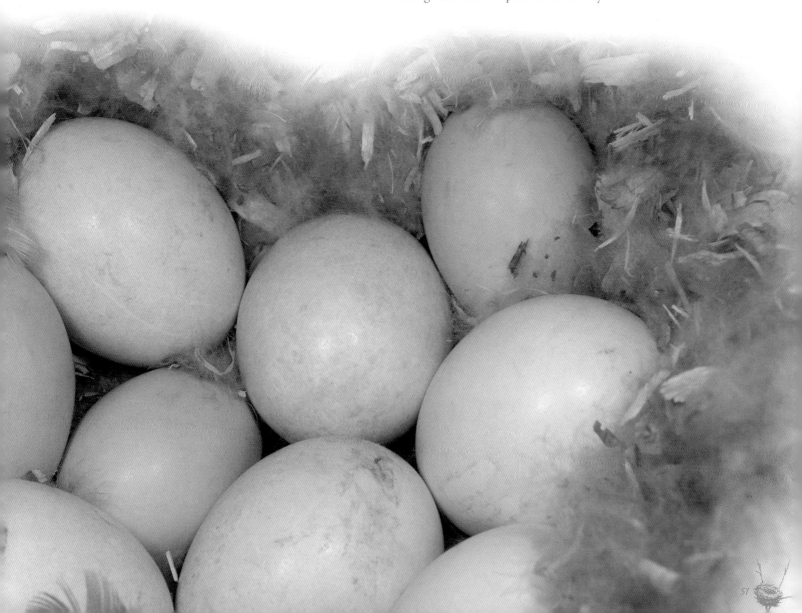

NEST RECYCLING Nest building takes a lot of energy and time, but most species don't reuse their nests. Nearly all open cup nests are used for only one brood. Once incubation is done and babies have left the nest, harmful ectoparasites are established, making the nest unsuitable for reuse. Not only that, nests with odoriferous accumulations are too risky to use again since some predators can find them just by following their noses.

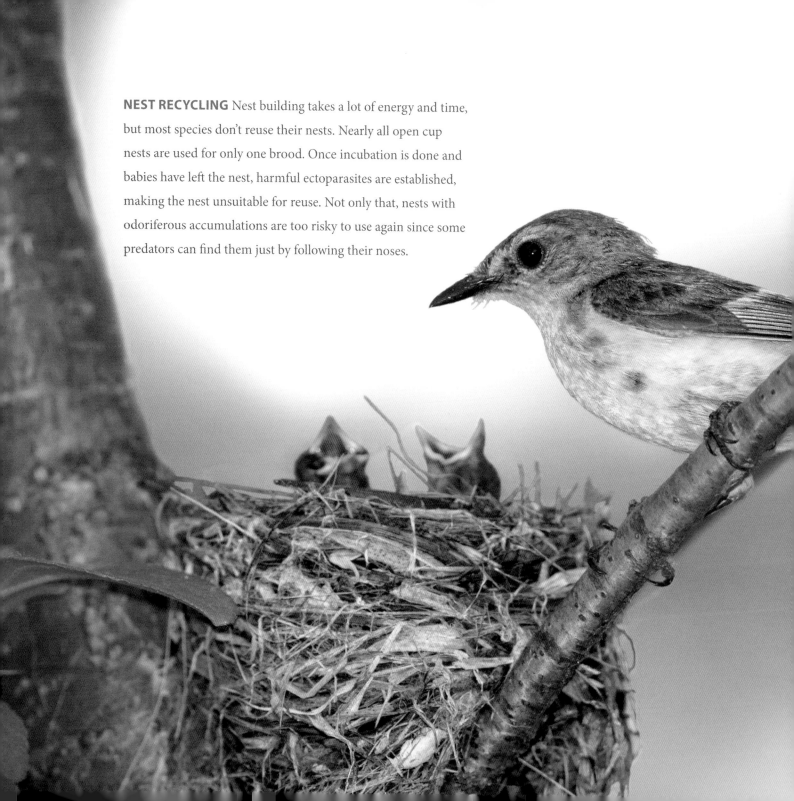

American
Redstart

Some of the more complex nests, such as pendulous nests, are occasionally refurbished and used a second or even a third time. Specialized nests, as well as very large nests, take so much energy to build that it makes sense to take advantage of the original effort spent, especially if the parents were successful at raising young there the previous year.

Large birds, such as Bald Eagles and Ospreys, regularly reuse their nests. Suitable trees in the right sites aren't very plentiful, adding to the incentive to renovate. So the birds add material, often creating a new top layer, and bring in fresh evergreen sprigs to repel parasites left from the last nesting season.

Cavity nests are often used more than once. Primary cavity nesters, such as woodpeckers, excavate their own cavities and usually don't reuse them. Secondary cavity nesters, such as Eastern Bluebirds, cannot excavate and will move in after the woodpeckers have left. Bluebirds often reuse the same nest cavity many times successfully. Unlike bluebirds, however, studies show that Yellow-bellied Sapsuckers, which sometimes reuse their old cavities, are not as reproductively successful in them as they are in newly excavated cavities. Presumably the presence of nest parasites is weighed against the effort it takes to construct a new cavity.

Eastern
Bluebird

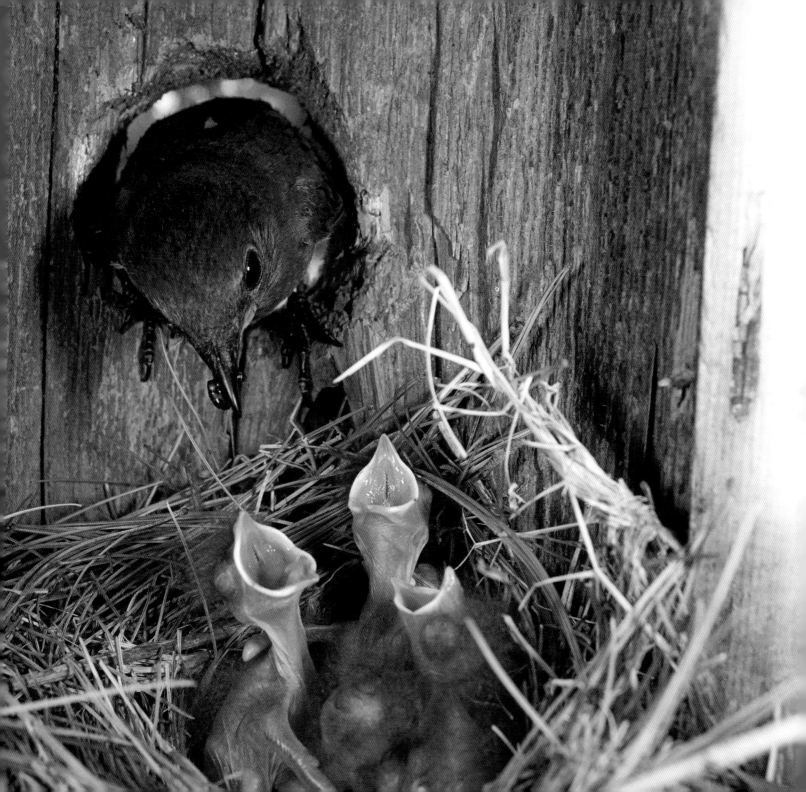

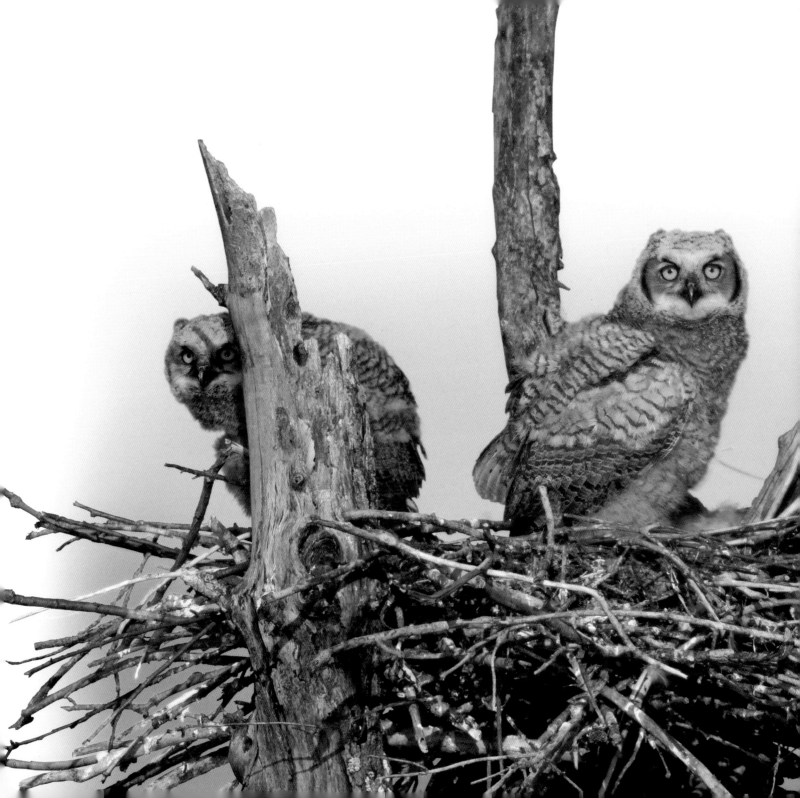

TAKEOVER OPPORTUNITIES Some bird species don't build their own nests—they appropriate, or take over, other nests. Solitary Sandpipers appropriate the nests of small birds and simply move right in. Great Horned Owls take the nests of Great Blue Herons, Red-tailed Hawks and American Crows without bothering to add any nesting material. For years I observed a pair of Great Horns nesting in a Great Blue Heron nest, right in the middle of the heron colony. It was strange to see predator and prey nesting in the same tree at the same time! Great Horns are early nesters, starting their nest selection in January and February, well before the previous owners are even thinking about it.

Great Crested Flycatchers take over any available open cavity—I once saw one nesting in a mailbox! Often they will reuse the same cavity for many years.

Great Horned
Owl

NEST PARASITISM Brown-headed Cowbirds have an uncommon nesting behavior. The females don't build their own nests—or even incubate their own eggs. Instead, they lay speckled eggs in the nests of other species, leaving the host parent, such as a Chipping Sparrow or Eastern Phoebe, to incubate and raise cowbird young. This behavior, called nest parasitism, is considered advanced evolutionary strategy. It's fairly common in Old World birds but unusual in North America.

Brown-headed Cowbird
and Eastern Phoebe

Brown-headed Cowbird
and Chipping Sparrow

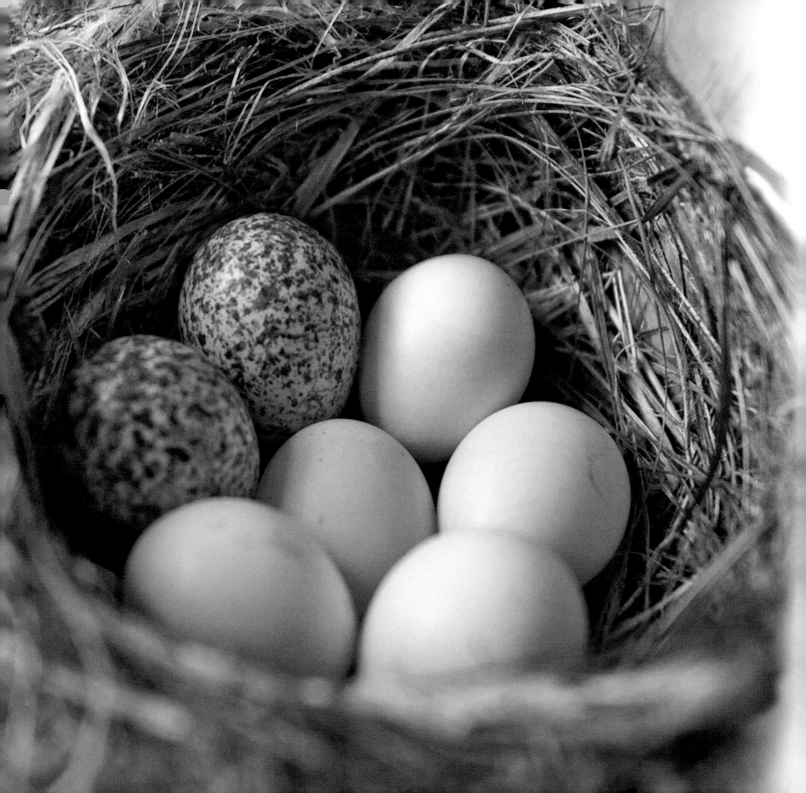

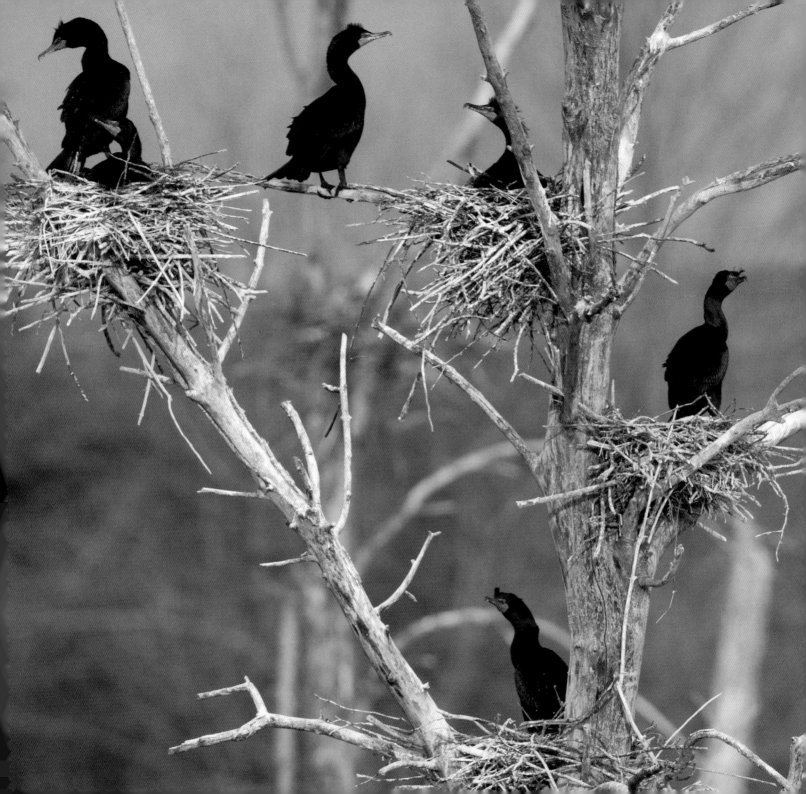

Birds at Work

REGARDLESS OF WEATHER CHANGES, birds don't try to build a different kind of nest in other seasons or years. Each species makes just one type of nest, consistently. While much of their ability to construct a nest is genetic, some species need to practice and perfect the process. Initially, some birds will build a partial or even a complete nest and then abandon it. Other species don't attempt construction until they are 5–7 years of age.

Double-crested
Cormorant

61

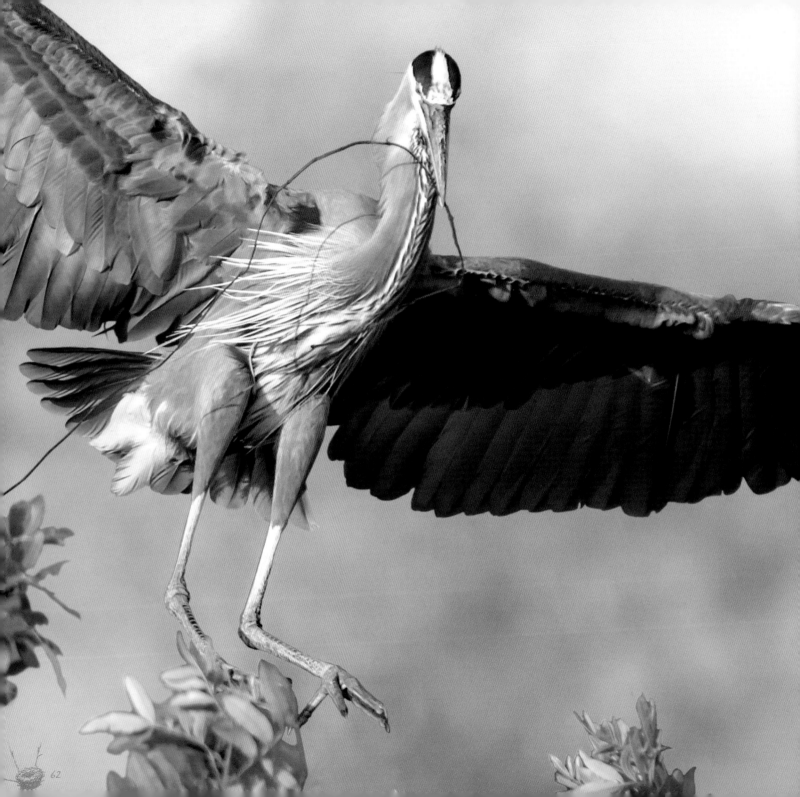

THE CONSTRUCTION CREW In nature, diversity rules! You can see one sex or the other building the nest and all variables in between. In many species, females select the sites and build the nests. In others, males help bring in bits of material. Often males just rearrange the nest, making a minor contribution. This is common in Eastern Bluebirds and other species with brightly colored males and duller females.

Ruby-throated Hummingbird males don't help build nests or raise young. The females do it all, from nest site selection to construction to feeding the babies. Woodpecker males, however, do the majority of the building. They also choose sites and bring in the most materials.

Phalaropes are unlike most other birds. Females are larger and more brightly colored than males, and they act more like males than females. They also compete for territories and fight each other for the available males. They often lay eggs in different nests built by multiple males and then migrate south, leaving the males to incubate and raise the young on their own—true role reversal.

When both sexes look similar, they generally share the nest building tasks equally. Male crows, jays, swallows, egrets, gulls and herons gather the most nesting materials, and females arrange and shape the nests.

Great Blue
Heon

THE AVIAN TOOLKIT The bill is a multi-tool of the most natural kind. It serves as a drill when the bird excavates holes in wood or burrows into the ground and digs out a nest chamber. The bill also works like a needle to sew vegetation together, like a trowel to plaster mud, and as a forceps or tweezers to pull and pick up materials.

Bringing in nesting material is limited to how much a bird can hold in its bill or carry with its feet. Some species take just a tiny bit of material to the nest over and over again. Other birds, such as American Robins, stuff their bills with everything they can possibly fit before returning to the site.

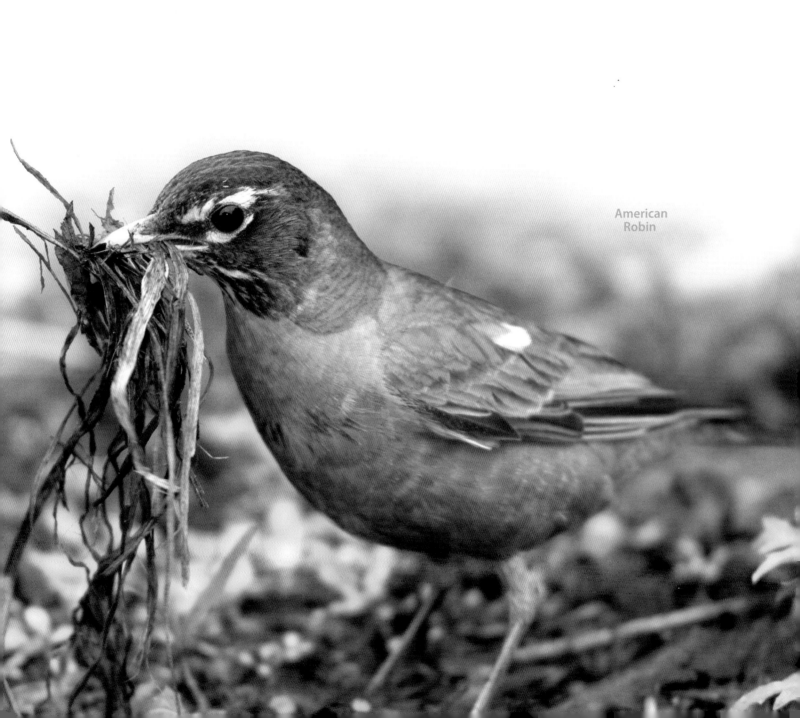

American
Robin

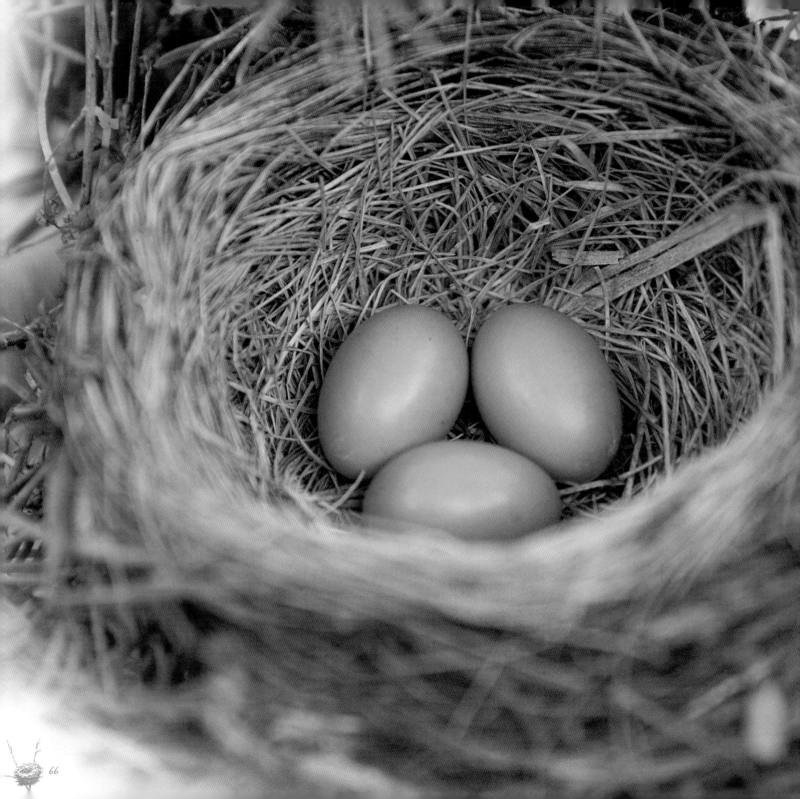

BUILDING SKILLS Open cup nest construction on branches or platforms starts at the bottom and works up to the top. Dangling nests, such as the pendulous nests built by White-eyed Vireos, start at the top and work down to the bottom.

Weaving nest material seems simple enough until you give it a try yourself. Birds are master weavers, making a variety of hooks, interlocking loops, coils, knots, hitches and much more. Birds also use different techniques of weaving and knotting. Some tie simple knots, others use half hitches, and still others make slipknots. Birds spend lots of time poking and prodding nest material to weave it strongly. I've often watched Baltimore Orioles poking their bills through nest walls like sewing machine needles as they weave their hanging nests.

Mud nests are labor intensive. A Barn Swallow must fly repeatedly to the nest site with a dab of mud in its beak. Just one nest can require about 1,400 dabs of mud! Barn Swallows were originally cave nesters, plastering their nests to the walls. By the mid-1900s, they shifted almost exclusively to man-made structures that provided a roof or overhang for protection, simulating the caves of old.

American Robin

GETTING THE JOB DONE The time needed to build a nest depends on the type of nest and the climate. Simple scrape nests take only moments to make. Others take much longer. Mourning Doves build loose platform nests in two days. Typical North American songbirds, such as Yellow Warblers, construct open cup nests in about six days. It usually takes three days to make the coarser, outer part of the nest and three days to fashion the finer inner lining. These nests take hundreds of trips to complete. Each piece of plant material, small or large, must fit together to make a satisfactory final structure. Larger stick nests, such as those made by American Crows, take upwards of two weeks to build.

Black-legged
Kittiwake

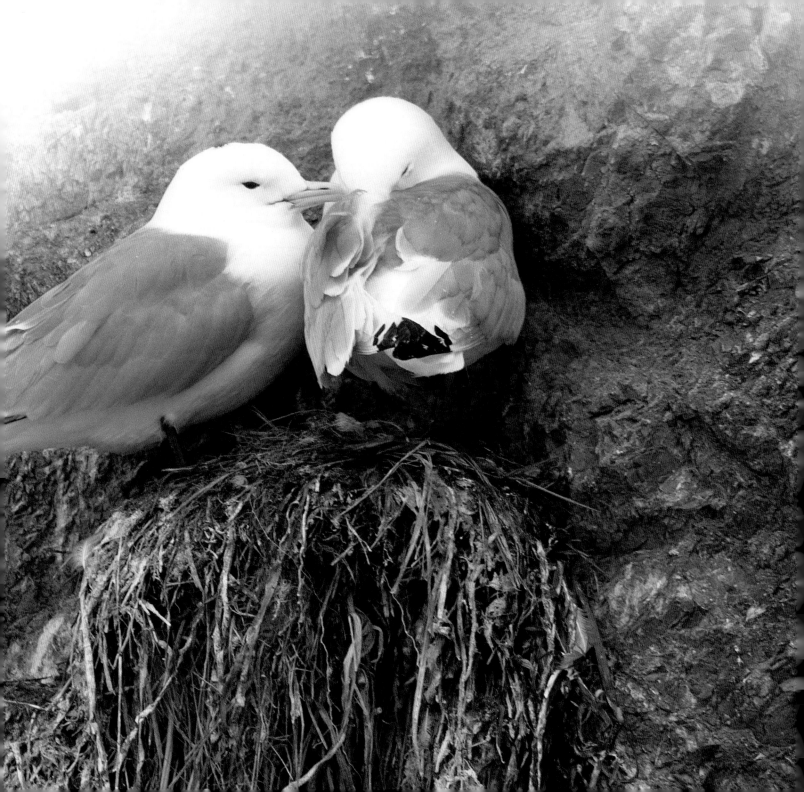

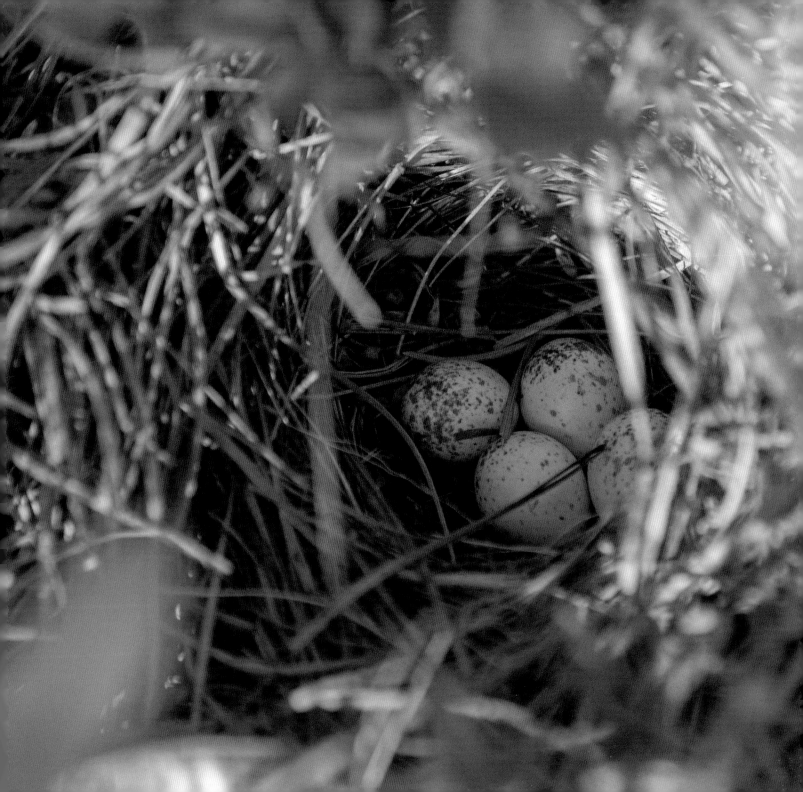

A Look Inside the Nest

NESTS AND EGGS are some of nature's most amazing products! As a naturalist I have shown hundreds of children and adults different nests and eggs, and the expression of joy on their faces is hard to forget. Finding a tiny nest filled with precious eggs is a beautiful experience. When you look at a nest, you can almost see all the hard work and care it took to build as a safe place to lay eggs.

Kirtland's Warbler

EGGS—A COMPLETE LIFE PACKAGE For millions of years, birds have reproduced by laying eggs in nests. Today, all of the world's approximately 10,000 bird species lay eggs. An egg contains all the nutrients and water required to help an embryo transform from a single cell into a hatchling. Eggshells must be dense enough to retain nutrients and water, yet strong enough to withstand the mother's weight and the bumping and rolling that occurs during incubation. They can't be too thick or the chicks will be trapped inside, and they need to be thin and porous enough to let oxygen enter so the chicks can breathe.

An eggshell's hard surface consists of a number of mineral layers, like glass layers in a windshield. A thin outer membrane sticks to the innermost layer of the shell, and an inner membrane envelops the egg white (albumen). It is the inner membrane that can be difficult to remove when you peel a hard-boiled egg. Another membrane covers the egg yolk and holds it together. You rupture this membrane when you break an egg yolk for breakfast. Egg yolk contains all the essential fats and proteins to feed the growing embryo. Young that have left the nest right after hatching, such as ducklings and goslings, have had much larger egg yolks than songbirds, which spend a lot of time developing in the nest after hatching.

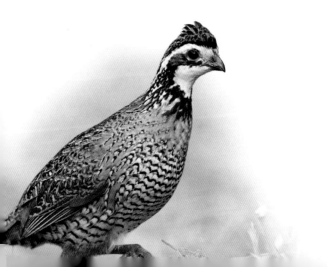

Northern
Bobwhite

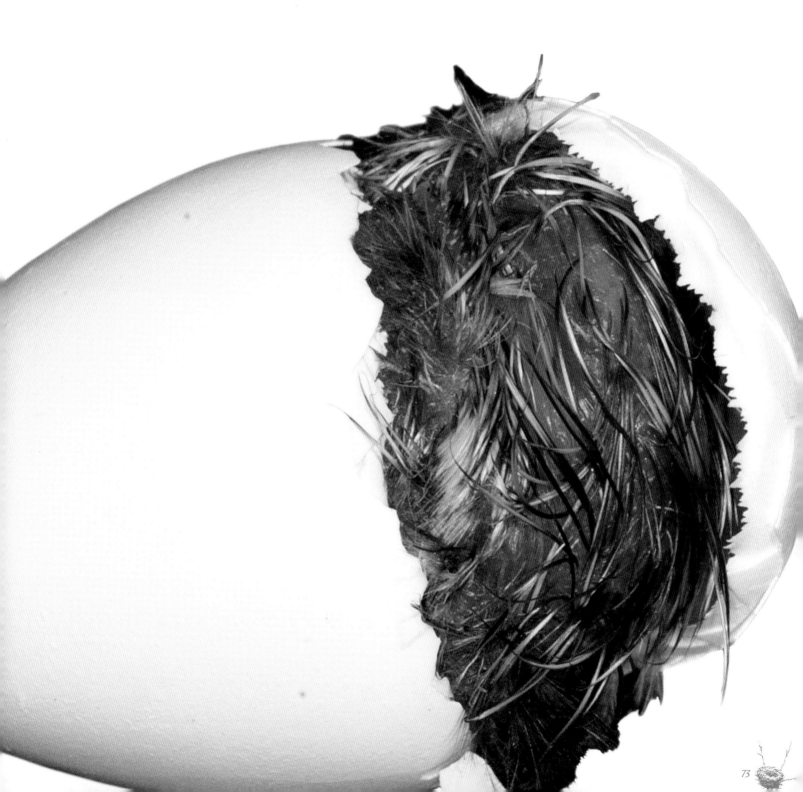

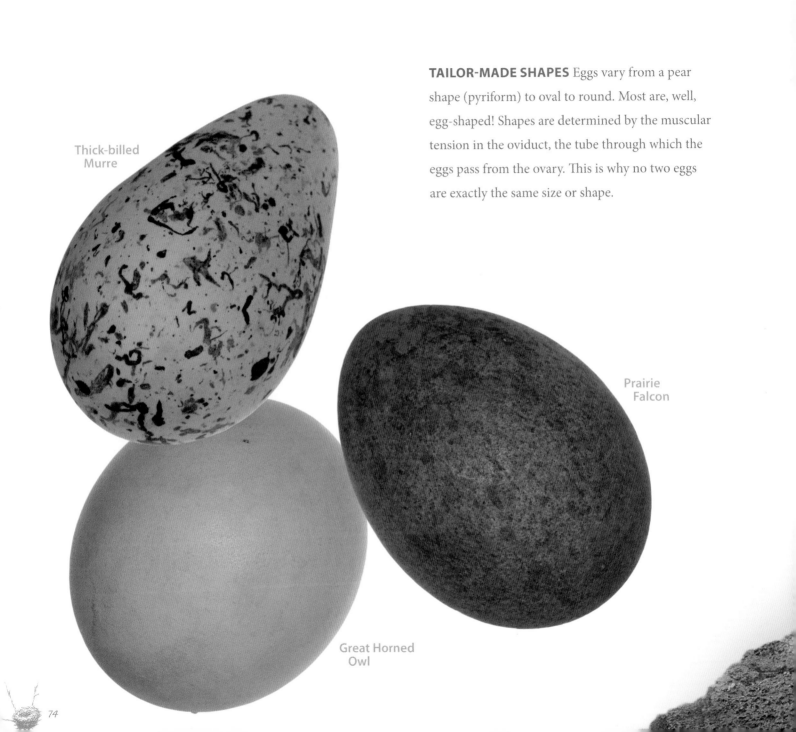

Thick-billed
Murre

TAILOR-MADE SHAPES Eggs vary from a pear shape (pyriform) to oval to round. Most are, well, egg-shaped! Shapes are determined by the muscular tension in the oviduct, the tube through which the eggs pass from the ovary. This is why no two eggs are exactly the same size or shape.

Prairie
Falcon

Great Horned
Owl

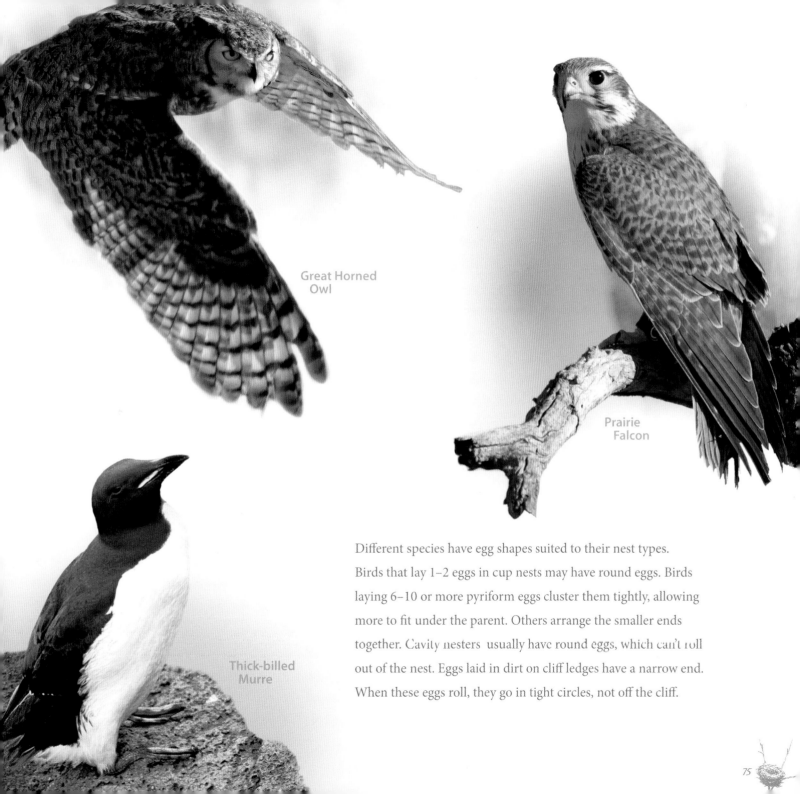

Great Horned
Owl

Prairie
Falcon

Thick-billed
Murre

Different species have egg shapes suited to their nest types. Birds that lay 1–2 eggs in cup nests may have round eggs. Birds laying 6–10 or more pyriform eggs cluster them tightly, allowing more to fit under the parent. Others arrange the smaller ends together. Cavity nesters usually have round eggs, which can't roll out of the nest. Eggs laid in dirt on cliff ledges have a narrow end. When these eggs roll, they go in tight circles, not off the cliff.

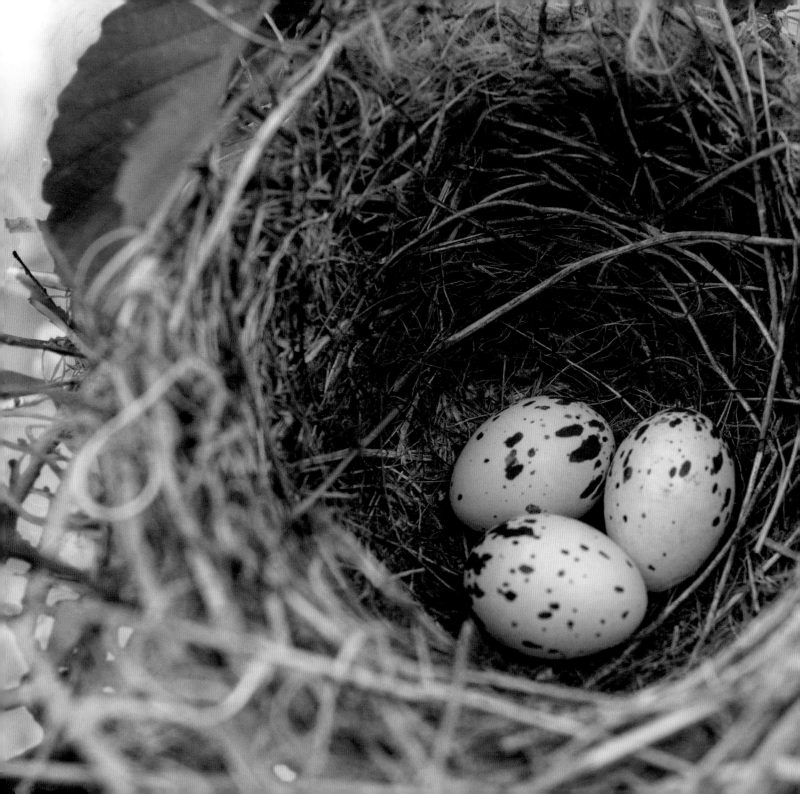

PIGMENTS AND PATTERNS Most bird eggshells have some kind of pigment. Pigments are added to newly formed eggshells just before they are laid. Background color appears first, followed by camouflaging spots, streaks or other marks. In most species, eggshell color and markings are fairly consistent and can help identify the birds in the nest. Colony-nesting birds, such as murres, have various colors of eggs and are the exceptions. Murre parents use their uniquely colored eggs to identify their nests after returning from feeding.

Raptors tend to have plain white eggs. As predators, they typically don't fear other birds and have no need to hide or camouflage their eggs.

Eastern Kingbird

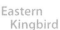

THE CLUTCH The process to produce an egg within the oviduct takes 24 hours or more. Thus, birds can lay only one egg per day or one every other day. Most birds lay eggs early in the morning. Egg laying lasts just seconds to an hour, depending on the species. The smaller the bird, the faster the egg is laid. Ducks, geese and other large birds have longer oviducts and need more time to lay an egg. Nest parasites, such as cowbirds, lay their eggs quickly. They sneak into a host nest, swiftly lay their egg and leave.

The clutch size, or number of eggs laid in one nest by one female, varies among the birds. Nearly all hummingbirds and most doves and pigeons lay just two eggs. Shorebirds usually lay four eggs. Our common backyard songbirds normally lay between two and six eggs. In general, birds that must feed their babies after hatching, such as nuthatches and chickadees, have smaller clutches. Grouse and turkeys, which have chicks that feed themselves after hatching, produce larger clutches.

Nesters in open cups have smaller clutches than cavity nesters. In addition, younger females tend to lay fewer eggs than older birds. Also, laying later in the season produces fewer eggs. Eastern Bluebirds nesting in spring, for example, lay up to six eggs, while those nesting in summer lay only four.

Eastern
Bluebird

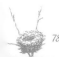

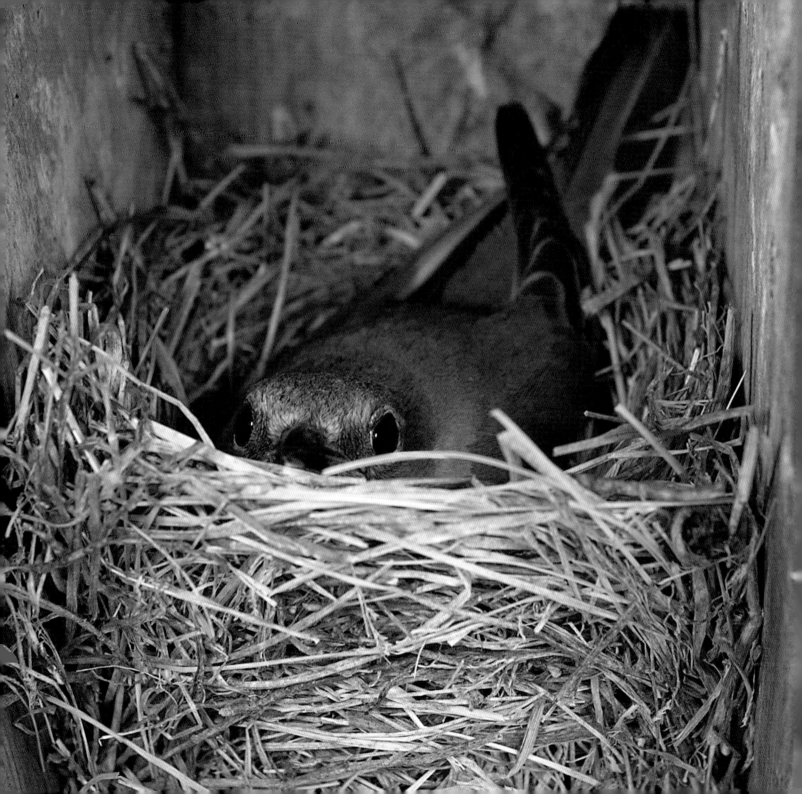

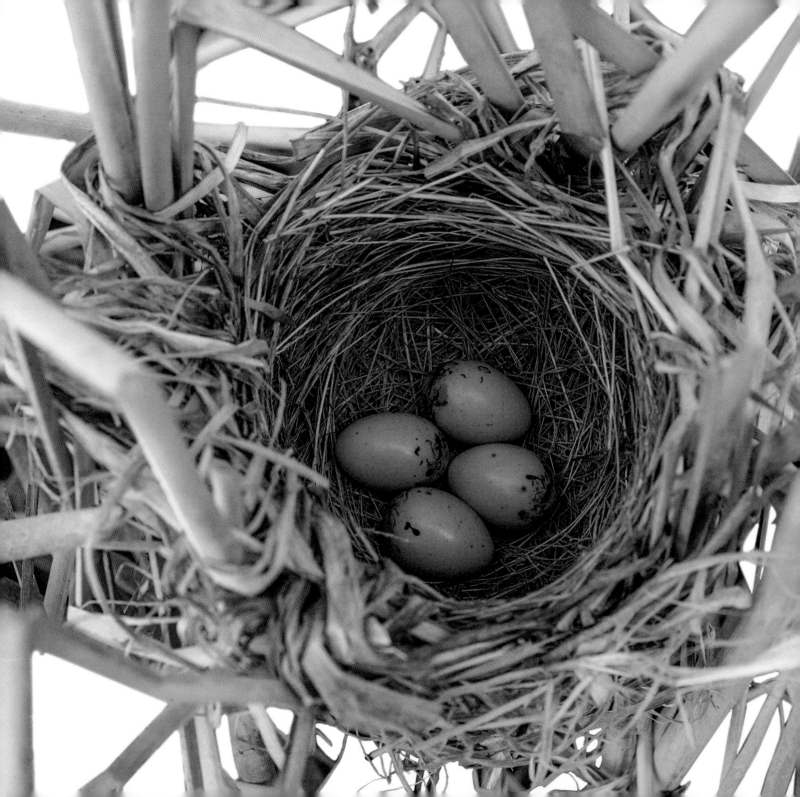

Generally, species with a widespread range, such as Red-winged Blackbirds, have more clutches with fewer eggs in each clutch per season in southern states than in northern locales. A Red-winged in Texas, for example, can raise two broods in a breeding season with three eggs per clutch, but in Maine it only has time to produce one brood with five eggs.

When clutches are plundered, many species replace their nests and lay eggs again. Others nest annually and won't replace a lost egg. Determinate layers produce a specific number of eggs and no more, while indeterminate layers repeatedly replace eggs that are lost. Some species can lay absurdly high numbers of eggs when their eggs are repeatedly taken. In one experiment, a Northern Flicker laid over 70 eggs in as many days when scientists removed the eggs repeatedly from the nest. Normally this species lays only 6–8 eggs.

Red-winged
Blackbird

INCUBATION DUTIES Incubation is the process of warming an egg to a proper temperature throughout the development of a chick. Egg laying and incubating may have an advantage over the live birth of a mammal. In a live birth, the female bears all the responsibility. In birds, both parents can take turns incubating.

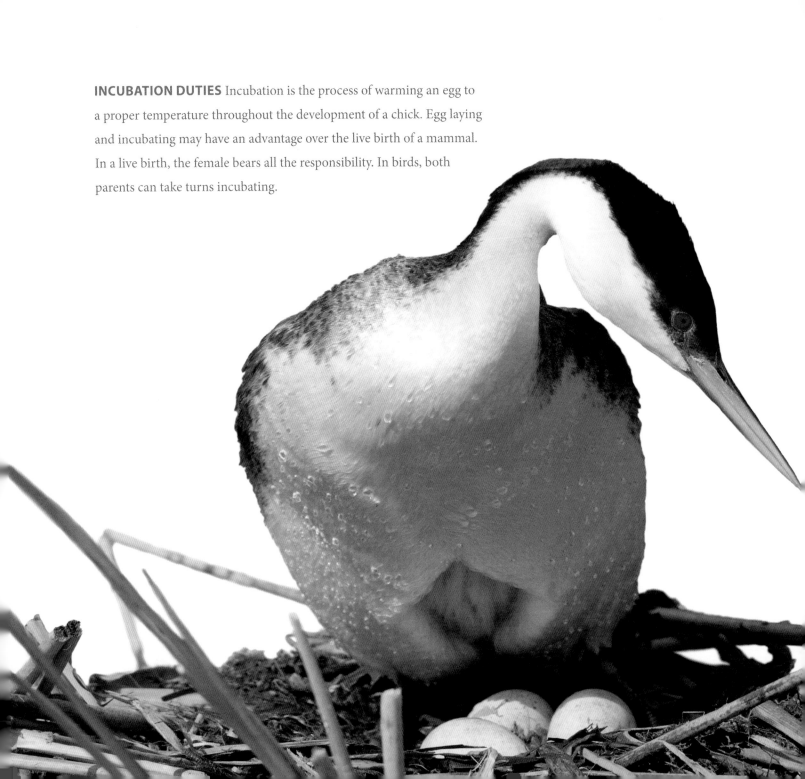

Most bird eggs require temperatures of 99–100 °F for successful incubation. Parents provide the heat, and most females do it by shedding or plucking feathers from their chests and bellies, creating a bare spot known as a brood patch. This allows direct skin-to-egg contact and transfers heat from the adult to the eggs. Short periods of cooling, such as when a female is off the nest, only slow the development of chicks. Freezing temperatures will kill them, so leaving eggs exposed during these times must be avoided.

In most small perching bird (passerine) species in North America, the females do all the incubating. Mother birds spend about 80 percent of their time sitting on eggs, but the length of incubation depends on the species. Small backyard birds have tiny eggs and short incubations of 10–15 days. Their chicks hatch naked with their eyes sealed shut, making them fully dependent on their parents. Ducks and geese incubate about 25–30 days. Their fully feathered chicks can care for themselves and are ready to leave the nest right after hatching. Hawks, owls and other large birds sit on their eggs for over a month before their chicks hatch.

Western Grebe

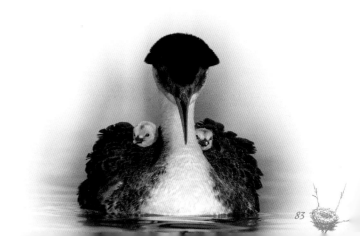

HATCHING BY EGG TOOTH Just before hatching, young birds develop an egg tooth. This is a short, sharply edged projection near the tip of the upper bill that will be used to pierce the shell. At this time the chick is completely filling the space within the eggshell and doesn't have much room to move. It's in the fetal position, with its head bent toward the belly. Lifting its head, it brings the egg tooth in contact with the eggshell. Slowly the chick rotates inside the shell, rubbing a consistent line around the wide end. Eventually it pips—meaning it breaks through, making a hole. Now you can hear it peeping and calling. Soon the blunt end cracks open, and the struggling chick emerges. The egg tooth has done its job, and within 24 hours it drops off or reabsorbs into the bill.

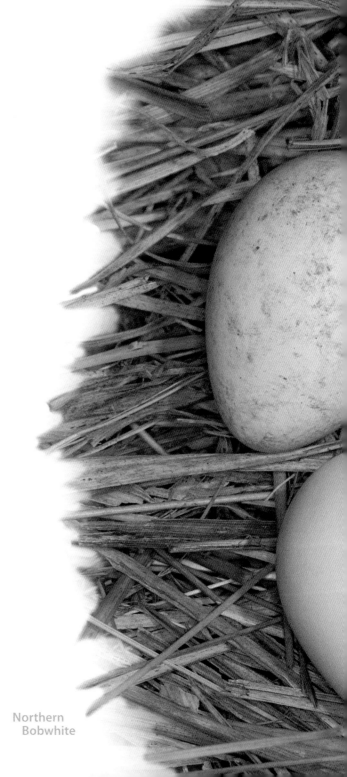

Northern Bobwhite

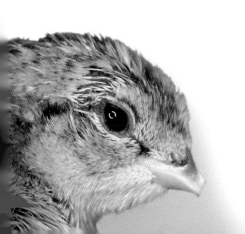

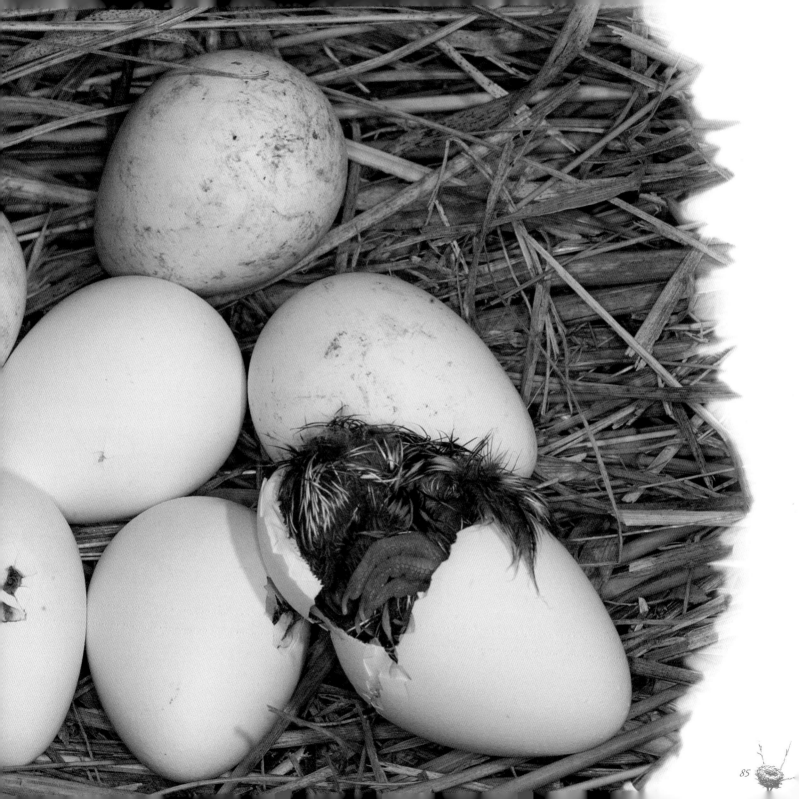

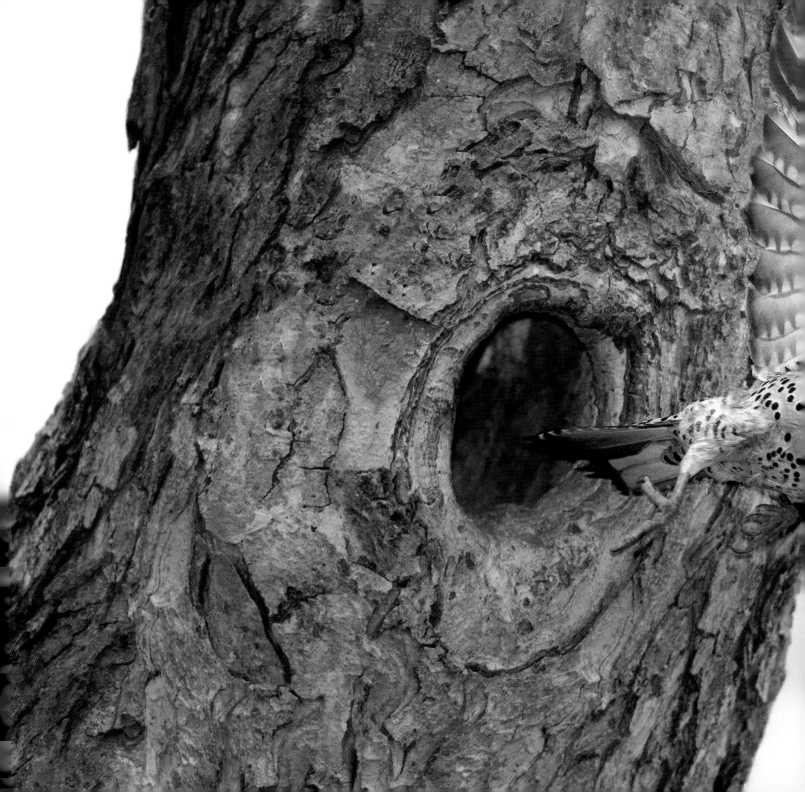

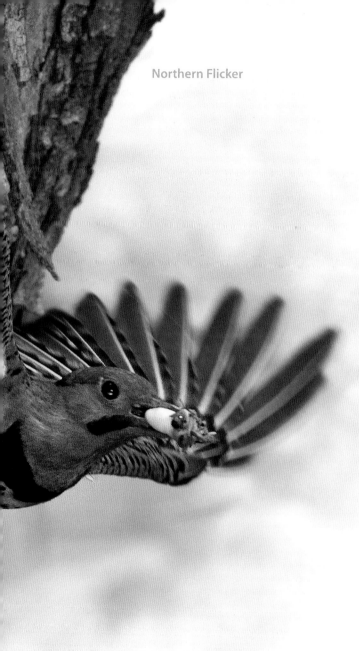

Northern Flicker

PACKET PICKUP Babies make a mess in the nest when they defecate, but fortunately, most birds are fastidious cleaners. After each feeding, a baby bird turns around, raises its bottom and excretes a white fecal packet encased in a thin membrane. The parent gently grabs the packet and flies off, dropping it well away from the nest. This helps keep the area clean and prevents predators and insects from being attracted to the nest.

Besides removing fecal sacs, the adults of some species also swallow the packets. The young can't digest all their meals, so their fecal sacs contain much nutrition. One study showed that up to 10 percent of an adult's daily nutrition is met this way. Indeed, nothing goes to waste in the natural world of birds.

Raptors are an exception to fecal packet production and removal. Baby raptors don't expel fecal sacs, and raptor adults lack the bill design for carrying such delicate packages. These babies move to the edge of the nest and deliver the feces over the rim, keeping the interior clean.

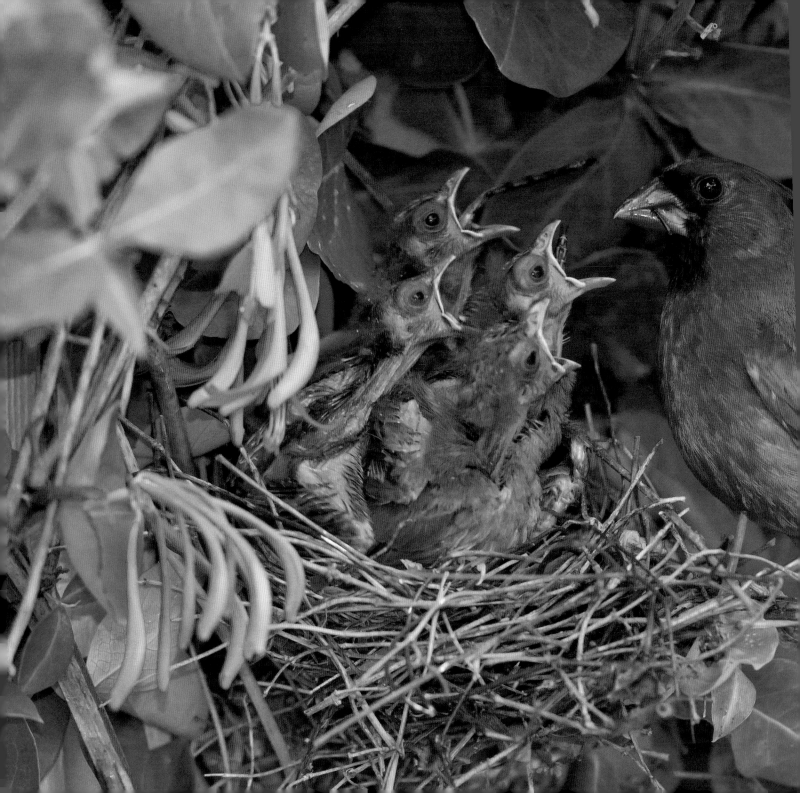

Backyard Birds

BACKYARD BIRDS BUILD some of the most interesting nests. These birds tend to be colorful or obvious and include Northern Cardinals, Blue Jays and House Finches. They build cup nests with twigs and strips of bark and often hide them well within thick vegetation. Most are located no more than 10 feet off the ground. Others can be as high as your tallest treetop. The number of nests in your yard depends on the quality of the habitat. Yards with food and water sources and lots of cover in which to hide from predators are likely to have birds setting up homes.

Northern
Cardinal

NEAT AND SWEET Warblers are a group of small, brightly colored songbirds that often nest in backyards. Yellow Warblers and American Redstarts are a couple of good examples. Female Yellow Warblers build strong, neat nests with weedy plant stalks, shredded bark and dried grasses. They select soft plant materials to line and shape the interior to their bodies.

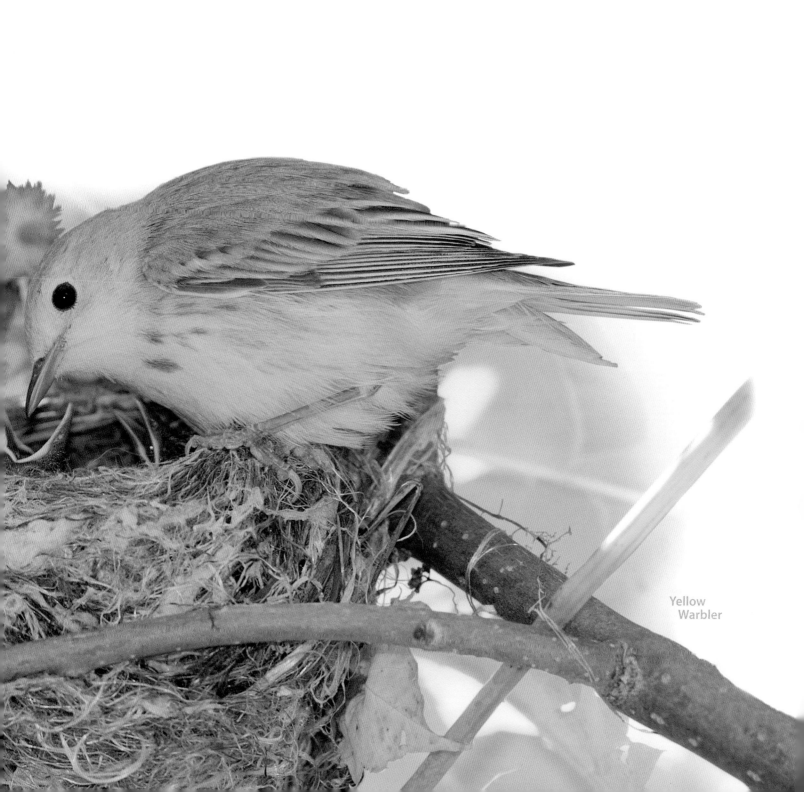

Yellow
Warbler

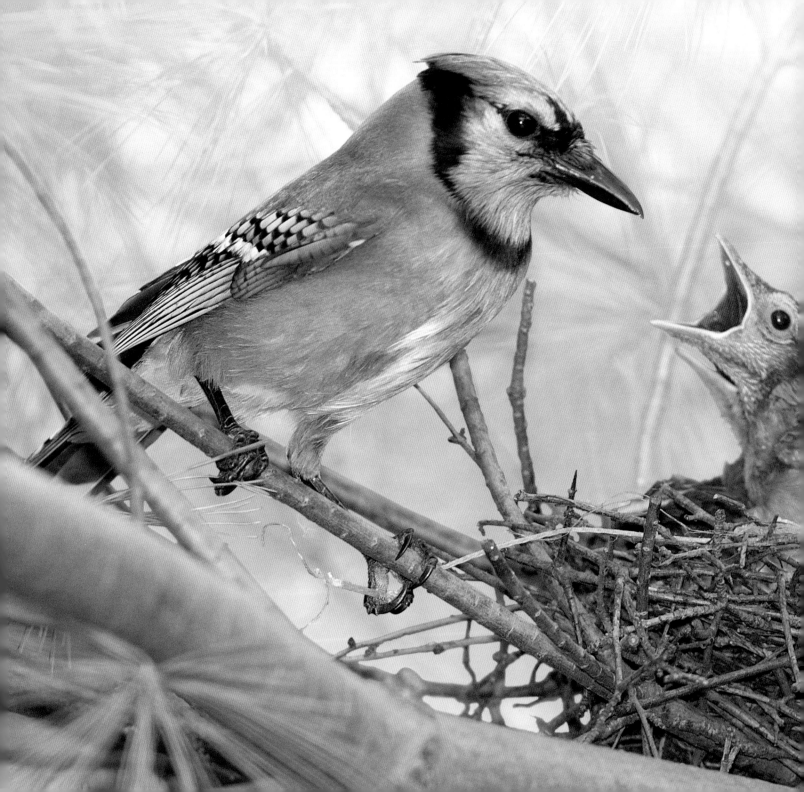

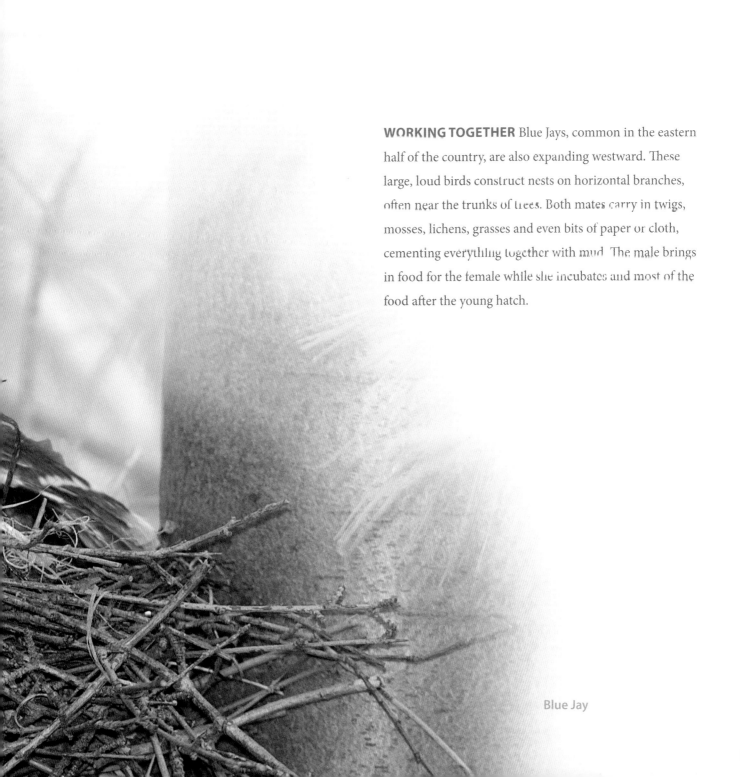

WORKING TOGETHER Blue Jays, common in the eastern half of the country, are also expanding westward. These large, loud birds construct nests on horizontal branches, often near the trunks of trees. Both mates carry in twigs, mosses, lichens, grasses and even bits of paper or cloth, cementing everything together with mud. The male brings in food for the female while she incubates and most of the food after the young hatch.

Blue Jay

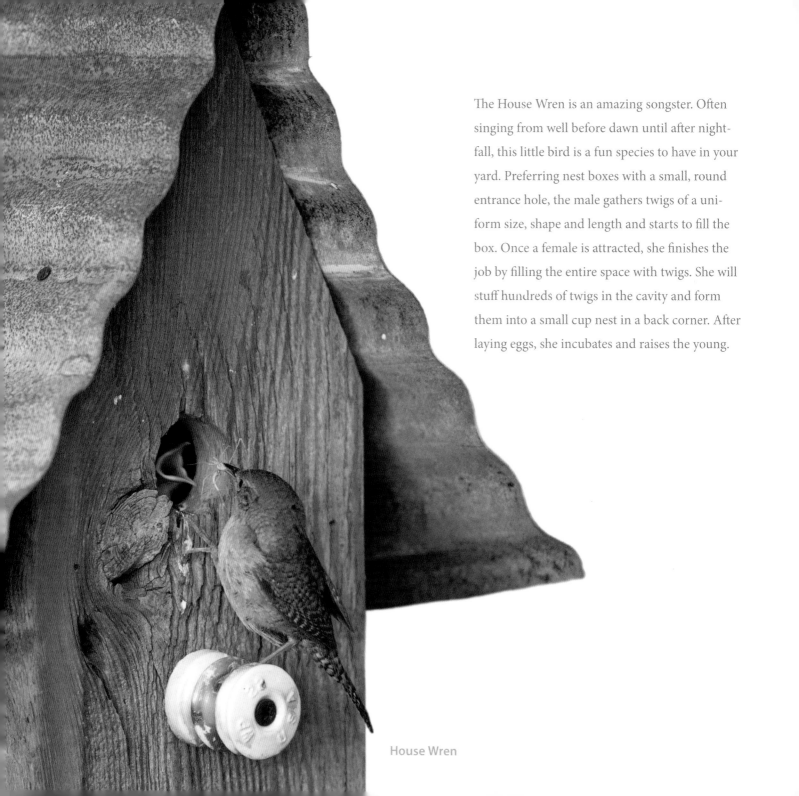

The House Wren is an amazing songster. Often singing from well before dawn until after nightfall, this little bird is a fun species to have in your yard. Preferring nest boxes with a small, round entrance hole, the male gathers twigs of a uniform size, shape and length and starts to fill the box. Once a female is attracted, she finishes the job by filling the entire space with twigs. She will stuff hundreds of twigs in the cavity and form them into a small cup nest in a back corner. After laying eggs, she incubates and raises the young.

House Wren

Cactus Wrens are found in backyards in the Southwest from Texas to southern California. Pairs make ball-shaped nests with a side entrance that utilizes prevailing winds to maximize heating, cooling and ventilation. For protection, they often build nests and raise families in needle-infested cholla cacti. They usually roost in needle-bound nests at night and may reuse them for many years.

Cactus Wren

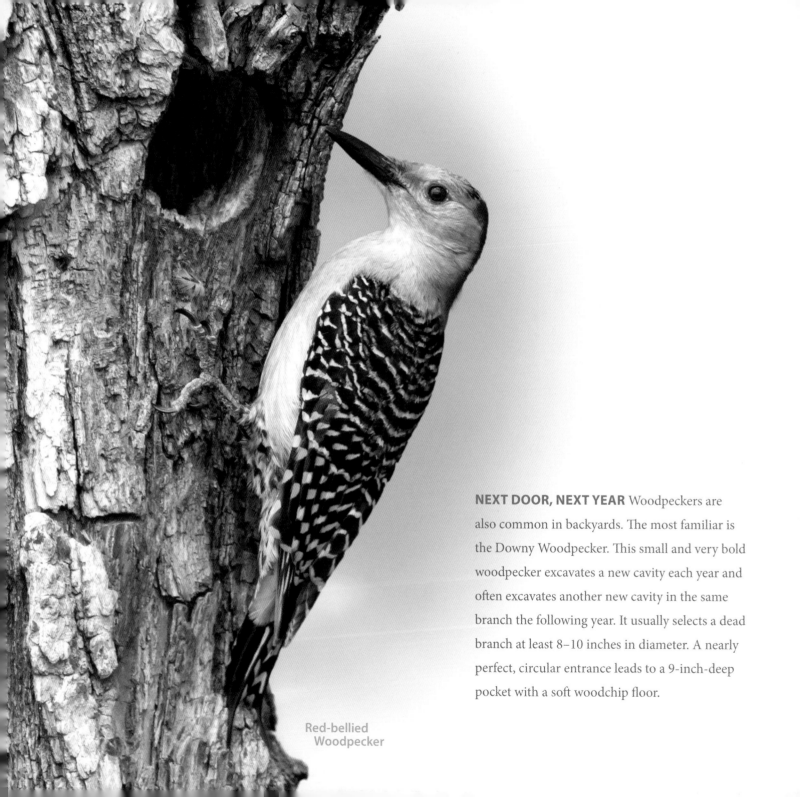

NEXT DOOR, NEXT YEAR Woodpeckers are also common in backyards. The most familiar is the Downy Woodpecker. This small and very bold woodpecker excavates a new cavity each year and often excavates another new cavity in the same branch the following year. It usually selects a dead branch at least 8–10 inches in diameter. A nearly perfect, circular entrance leads to a 9-inch-deep pocket with a soft woodchip floor.

Red-bellied
Woodpecker

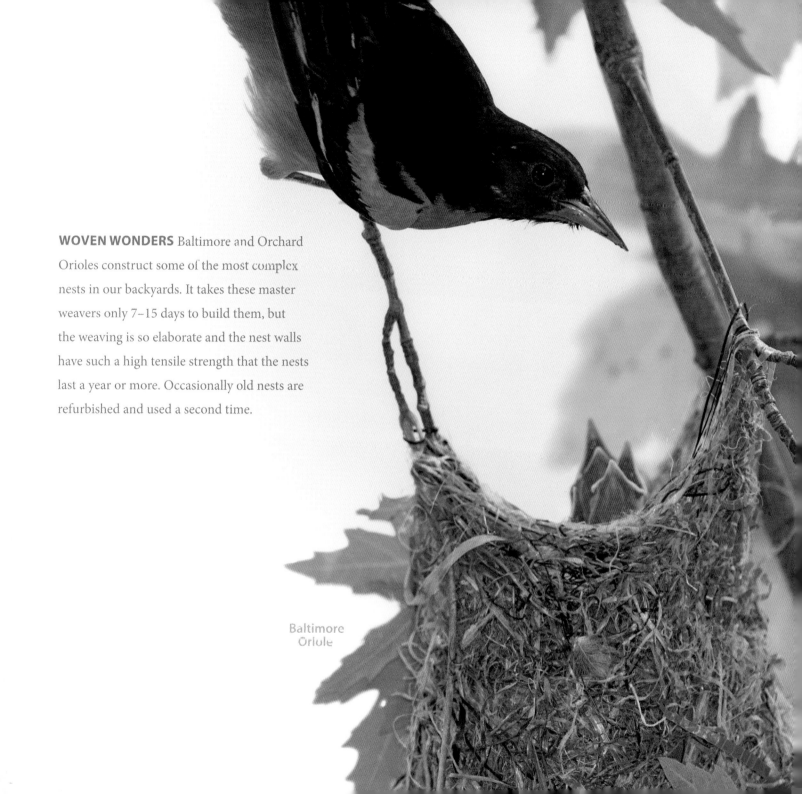

WOVEN WONDERS Baltimore and Orchard Orioles construct some of the most complex nests in our backyards. It takes these master weavers only 7–15 days to build them, but the weaving is so elaborate and the nest walls have such a high tensile strength that the nests last a year or more. Occasionally old nests are refurbished and used a second time.

Baltimore
Oriole

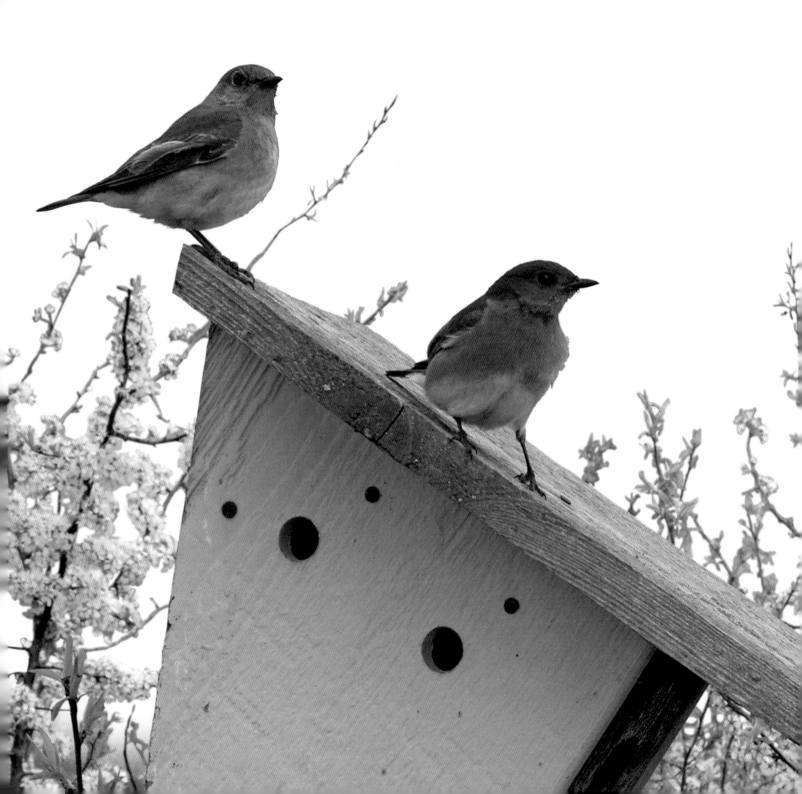

NEST BOX SUCCESS One of the best success stories in nature is the replenishing of the Eastern Bluebird. In the early to mid-1900s, the population of this beautiful songbird was at an all-time low due to lack of natural nesting cavities. Many thousands of bird enthusiasts have put up bluebird nest boxes since then, and today the population of the blue jewel is strong and healthy.

Eastern Bluebirds usually gather dried grasses for their nests. Sometimes they use other natural materials that are more readily available. On several occasions I discovered bluebird nests made with pine needles. It's always easy to identify Eastern Bluebird nests because each one is built with just one type of material.

Eastern
Bluebird

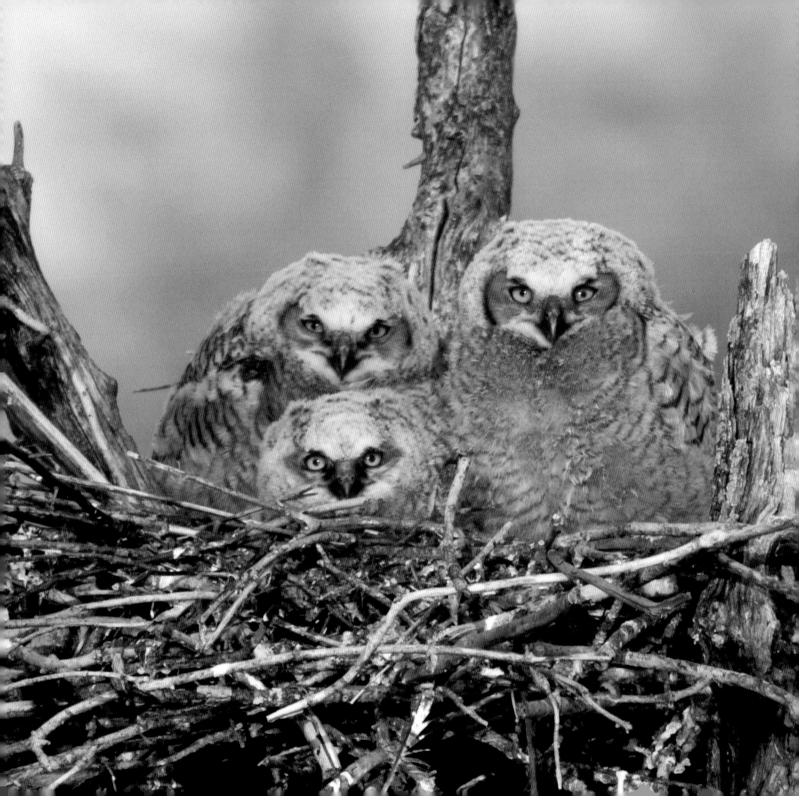

Raptors

MOST RAPTORS ARE LARGE BIRDS. Their nests range from scrapes to cavities and from small platform nests to massive stick nests. Many of our hawks, such as Broad-winged, Red-shouldered and Cooper's Hawks, construct traditional stick nests high in trees near the main trunk, where there is strong support. Falcons are interesting birds because they nest in a variety of ways—along ridges, on cliffs, in trees and within structures. Eastern Screech-Owls, Barred Owls and other night raptors use cavities for nesting, while Great Horned Owls claim the nests of hawks and other large birds as their own.

Great Horned
Owl

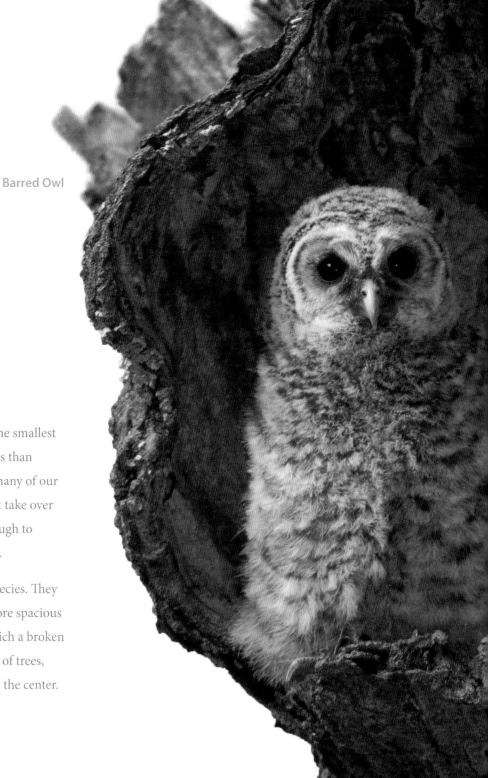

Barred Owl

OWLS IN THE CAVITIES Elf Owls are the smallest raptors in North America. Measuring less than 6 inches tall, they have a size similar to many of our sparrows. Elf Owls are cavity nesters that take over old woodpecker holes. They are tiny enough to occupy cavities too small for larger birds.

Barred Owls are one of our larger owl species. They also nest in cavities but require much more spacious homes. Typically, they prefer trees in which a broken limb has created a cavity, or open trunks of trees, where lightning has struck and damaged the center.

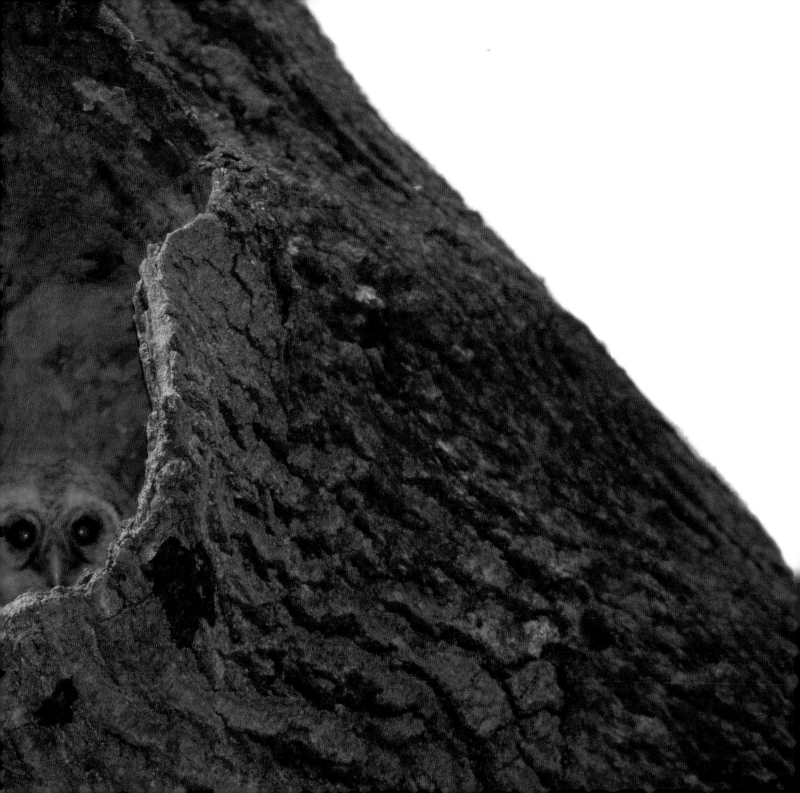

VARIOUS AND SUNDRY NESTS As a group, falcons have diverse ways to nest. American Kestrels are cavity-nesting falcons that reap the benefits from man-made nest boxes. Nesting, incubating and raising young inside nest boxes gives them added protection from the weather and larger predators. Merlins, which are similar to kestrels, construct traditional nests high in trees. Peregrine and Prairie Falcons make scrape nests on rocky cliffs. Crested Caracaras build their homes in palm trees, using the dense vegetation to help conceal their presence.

American Kestrel

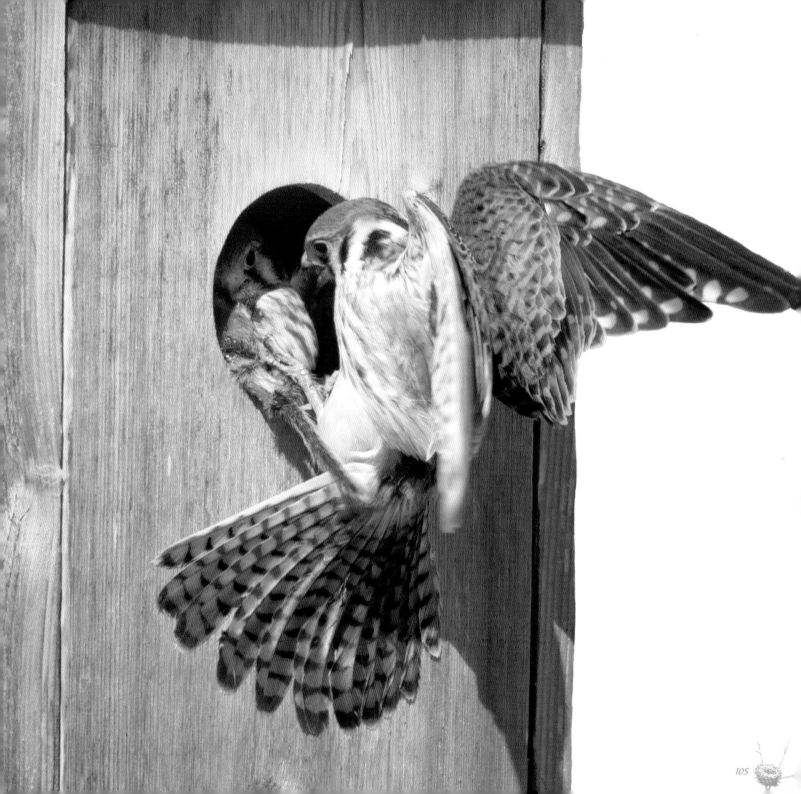

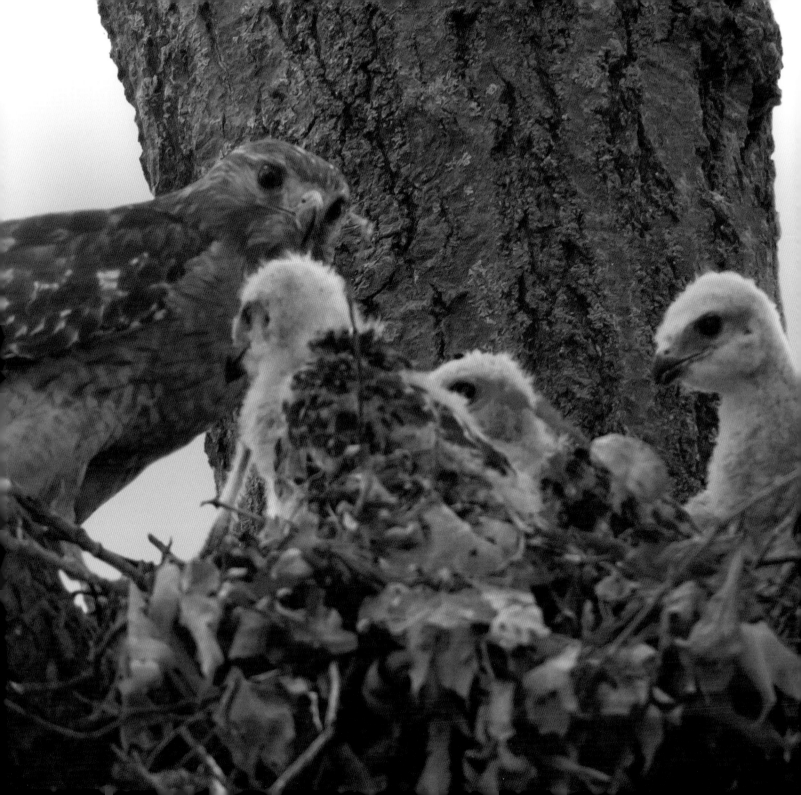

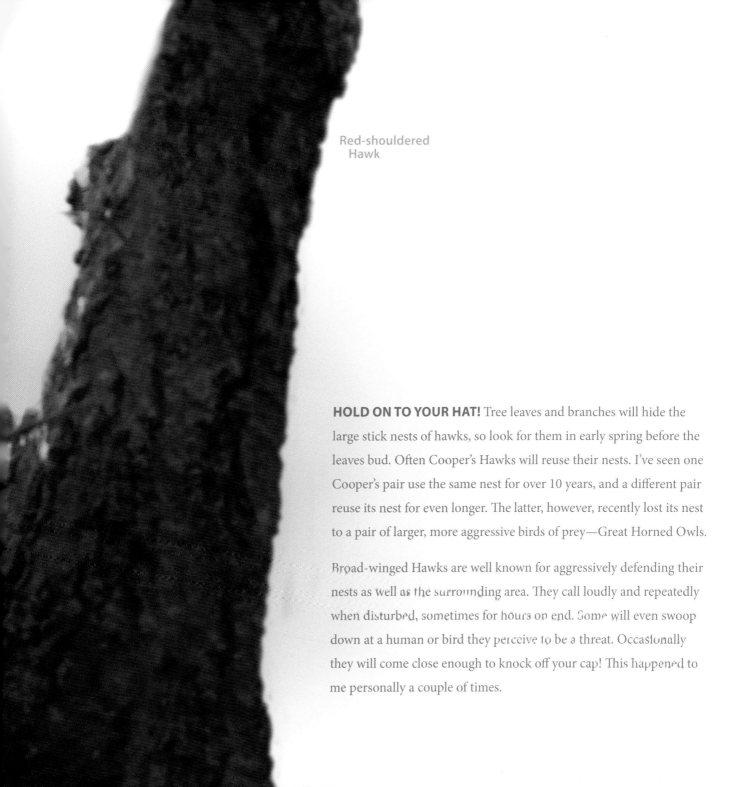

Red-shouldered
Hawk

HOLD ON TO YOUR HAT! Tree leaves and branches will hide the large stick nests of hawks, so look for them in early spring before the leaves bud. Often Cooper's Hawks will reuse their nests. I've seen one Cooper's pair use the same nest for over 10 years, and a different pair reuse its nest for even longer. The latter, however, recently lost its nest to a pair of larger, more aggressive birds of prey—Great Horned Owls.

Broad-winged Hawks are well known for aggressively defending their nests as well as the surrounding area. They call loudly and repeatedly when disturbed, sometimes for hours on end. Some will even swoop down at a human or bird they perceive to be a threat. Occasionally they will come close enough to knock off your cap! This happened to me personally a couple of times.

TOP OF THE HEAP Bald Eagles build some of the sturdiest nests, stacking branches in tall, strong trees. Adults are constantly adding sticks and remodeling, so the nests grow over the years and often are used for many generations. Usually they get nesting material by locating a dead tree with many branches. They fly to a branch, grasp it with their powerful feet and flap very hard. When the branch snaps, they keep flying and return to the nest. Once there, they use their bills to manipulate the new material and rearrange the nest.

Golden Eagles construct much more modest nests that measure only a couple feet thick, often on a cliff. These eagles also use their nests for many decades but don't add sticks, so their nests remain the same size.

Ospreys, large fish-eating raptors, often build platform nests on man-made nesting platforms or other structures. They bring in large sticks and even aquatic plants to make their nests, which they reuse. But unlike Bald Eagles, they don't add nesting materials repeatedly through the years. While they may add sticks here and there, the nest size generally stays unchanged.

Osprey

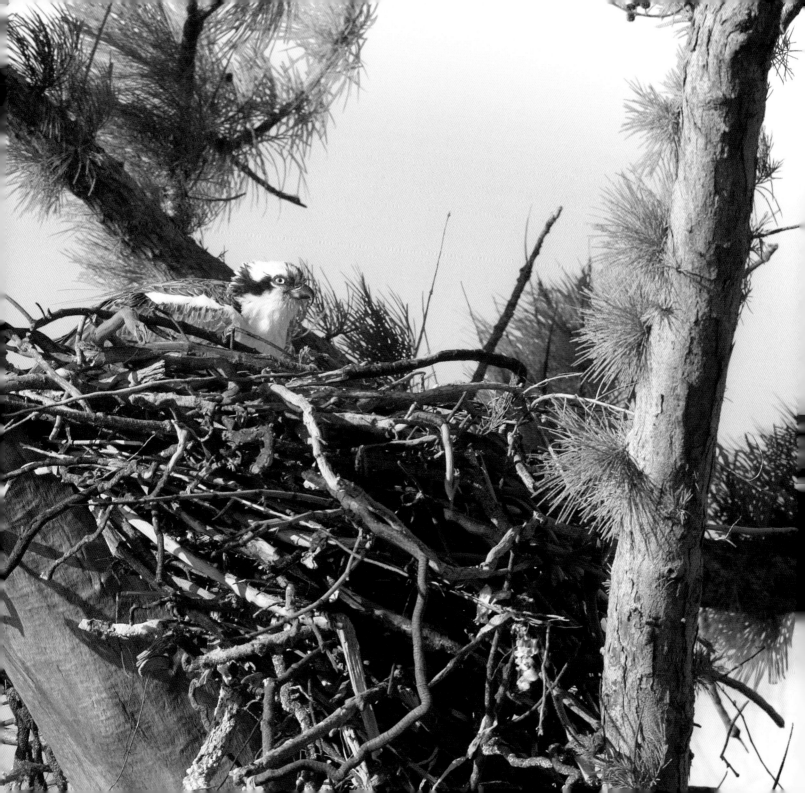

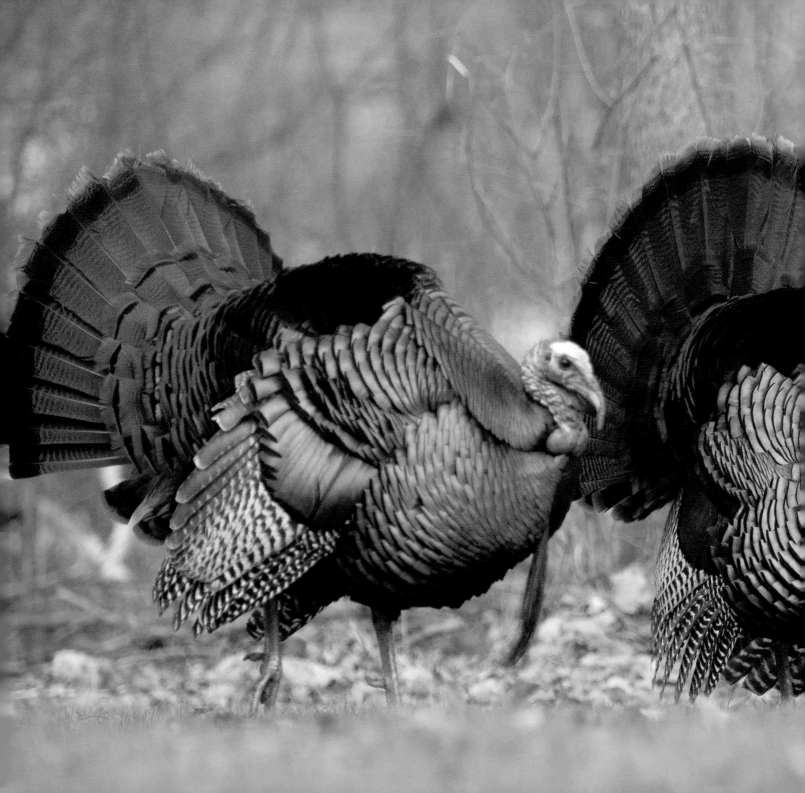

Game Birds

GAME BIRDS SUCH AS TURKEYS, grouse, quail and pheasant are all ground nesters. They make use of natural materials near the nest site but don't do much construction. They need to hide from skunks, raccoons, opossums and other predators, and often nest in thick grasses, a tangle of shrubs or other concealed places. Their earth-toned eggs go a long way to prevent visually acute predators from spotting an easy meal. Game birds tend to have camouflaging brown, black and white feathers, helping them blend into the environment. Many species sit for nearly a month incubating eggs, so it's important to stay quiet and undiscovered.

Wild Turkey

DANCING IN THE LEK Greater Prairie-Chicken males dance in a traditional arena, called a lek, to show off to the females. Dancing is a part of their exhibit of virility, prowess and strength. Males also fight among themselves while dancing and displaying, all for the right to mate with as many females as possible. After mating, the females build nests near the lek, usually hiding them deep in thick prairie grasses.

The American Woodcock, also known as Timberdoodle, is another species with an amazing courtship display. During spring, just after sunset, the male gives a raspy nasal call from an open meadow in the forest. Females watch from the ground as the male takes flight in the fading evening light. He twitters loudly and flies in tight circles above, displaying for the fascinated females. Suddenly he plummets back to earth, landing where he took off, and starts to call again.

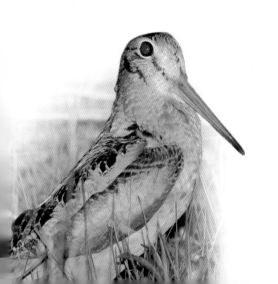

American
Woodcock

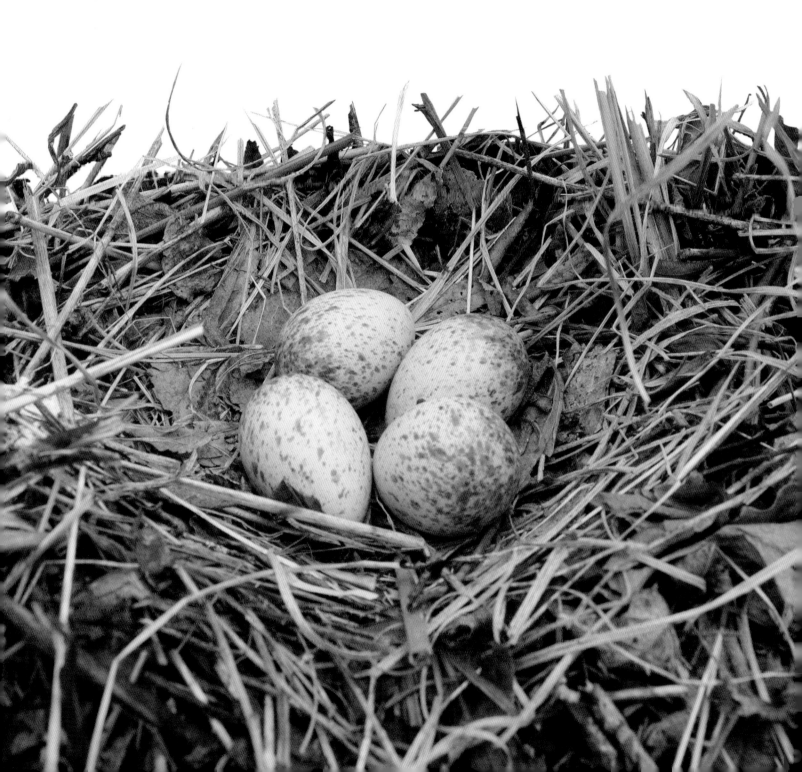

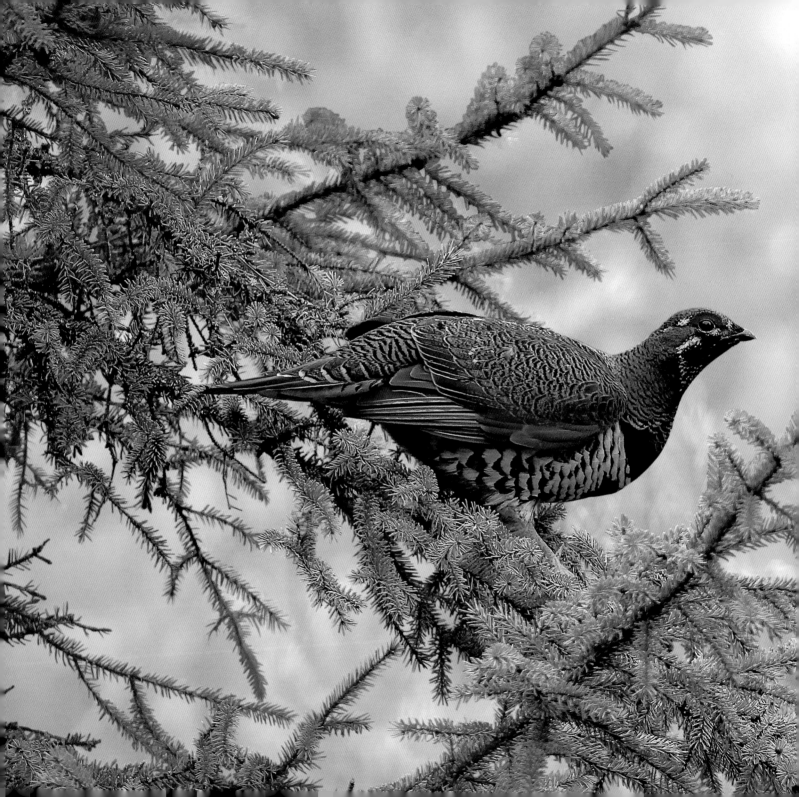

GROUSE AGROUND The Greater Sage-Grouse, the largest member of the grouse family, has an impressive spiked tail. Diminishing in population, this threatened bird builds its nest under sagebrush in a depression lined with grasses. It lays 6–9 eggs per clutch, which is fairly low for most grouse species.

The Dusky Grouse, formerly called Blue Grouse, is the western version of the Ruffed Grouse. Males display for females in open, high-elevation sagebrush habitat. The male fans his tail, inflates his neck sacs and struts on logs or stands on rocks to display. Suddenly he spring ups and somersaults in midair while clapping his wings loudly. The female builds a ground nest, often hidden under a fallen tree or thick shrub, or beside a log. She makes a shallow depression and lines it with vegetation and several feathers. Only 7–10 eggs are laid.

The Northwoods in Minnesota, Maine and other northern states are home to the Spruce Grouse, a habitat specialist that feeds on spruce needles and berries in boreal forests. It doesn't seem to fear anything, walking on the forest floor and allowing close observation. Nests are often tucked under low branches of fallen trees or placed safely by downed tree trunks. These are shallow nests, lined with dried leaves and grasses, coniferous needles and some feathers.

Spruce
Grouse

HIDDEN IN THE WILD The Wild Turkey is one of our largest game birds. It roosts in trees at night but nests on the ground. A female turkey selects a secluded area, often in tall grass or thick vegetation, to lay a large clutch of eggs—usually more than 10. Because she lays only one egg per day and the nest is unattended until all eggs are laid, the site must be well concealed. After the mother starts incubating, she sits motionless for nearly a month. A fox, coyote or other predator would love a turkey meal, so remaining hidden is vital.

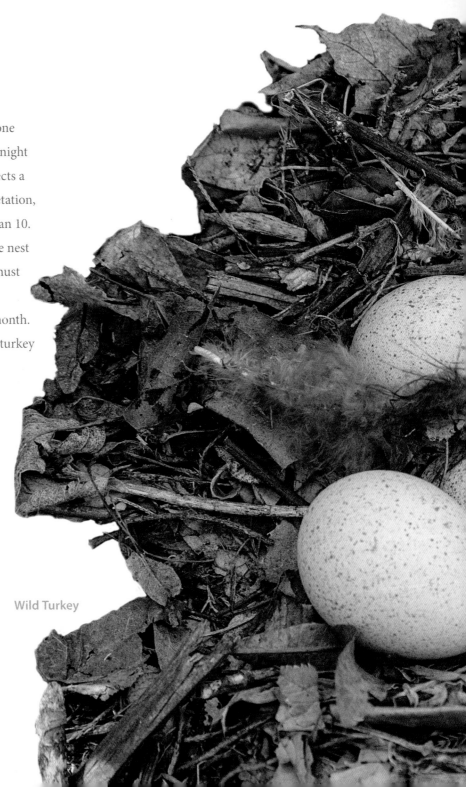

Wild Turkey

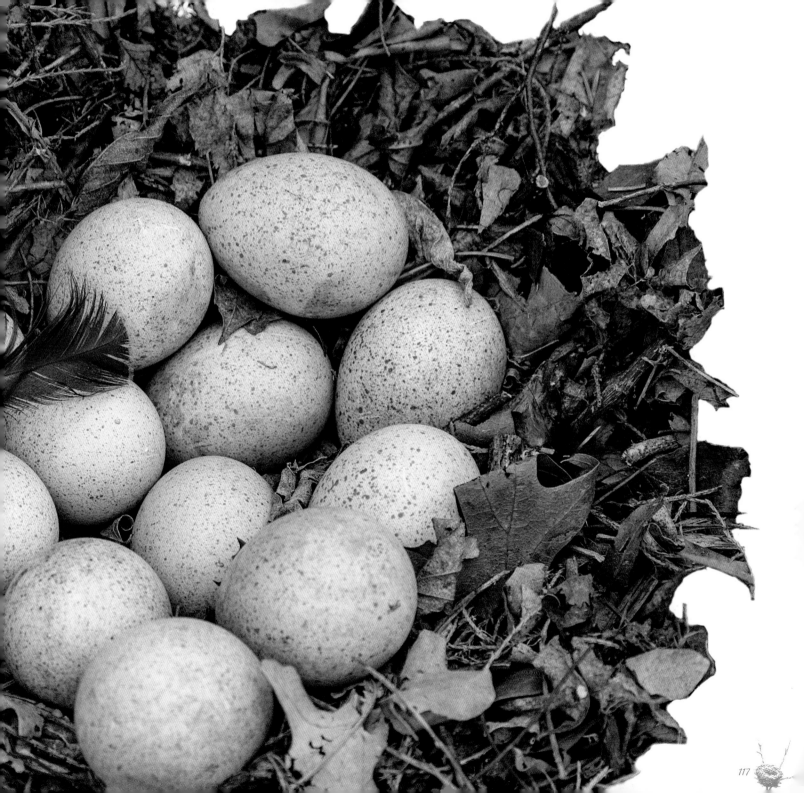

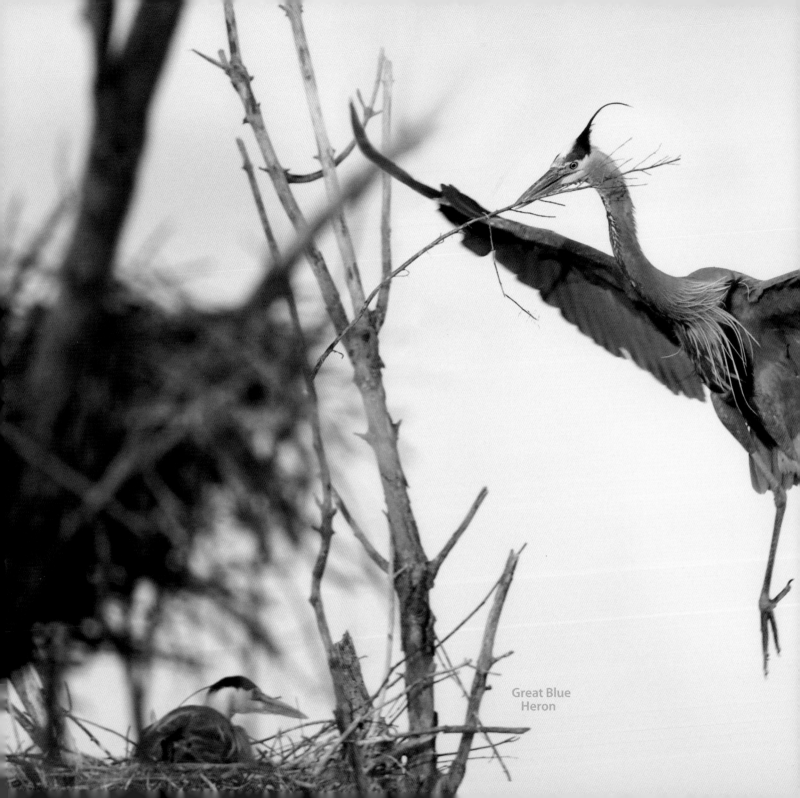

Great Blue
Heron

Water Birds

MOST OF OUR DUCKS, GEESE and other water birds nest on the ground. Large waterfowl, such as Snow Geese and Canada Geese, are ground nesters, as are Mallards, Northern Pintails, Blue-winged Teals, Ring-necked Ducks and other smaller species. Ground-nesting ducks conceal their nests in tall or thick vegetation, while geese, which defend nests aggressively, tend to choose open sites. Other water birds, such as Wood Ducks, Common Goldeneyes and Hooded Mergansers, nest in cavities, while long-legged Great Blue Herons and Great Egrets take to the trees. These colony-nesting waders carry sticks with their bills and make large platform nests on dead tree limbs, often over shallow water.

COLONY NEST MEDLEY Great Egret nests are easy to spot. The adults have beautiful breeding plumage, and they nest in small colonies. Often one tree has several nests, each in a different stage of construction and development. While eggs may be nestled in one nest, small chicks might be peeping out in another, with large chicks appearing in the rest. The nests are flimsy, made with a loose collection of dead and live branches. If a nest survives the year it will be used again, but many blow down during the interim.

Great Egret

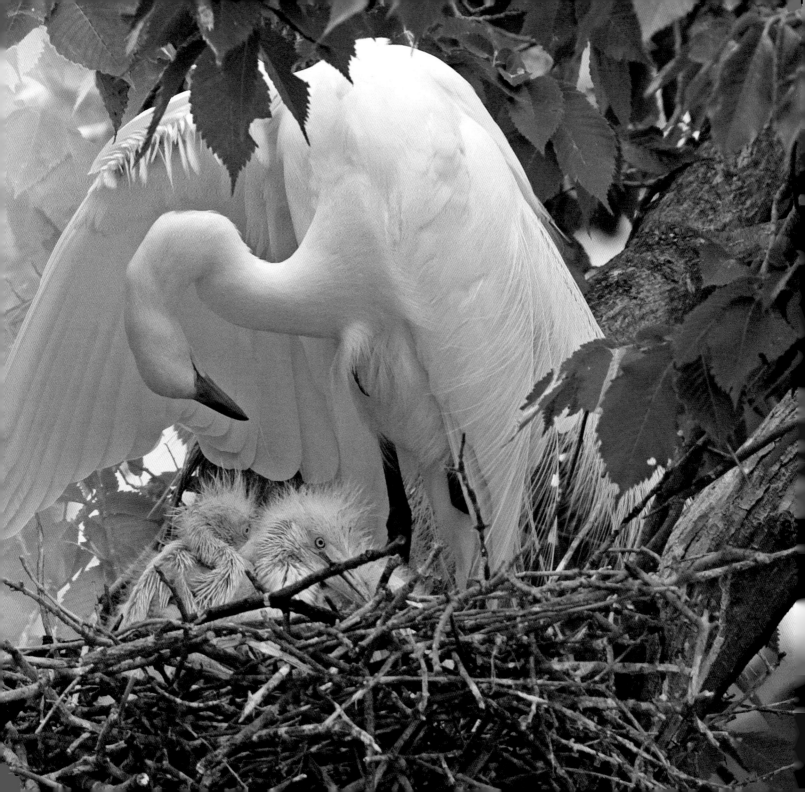

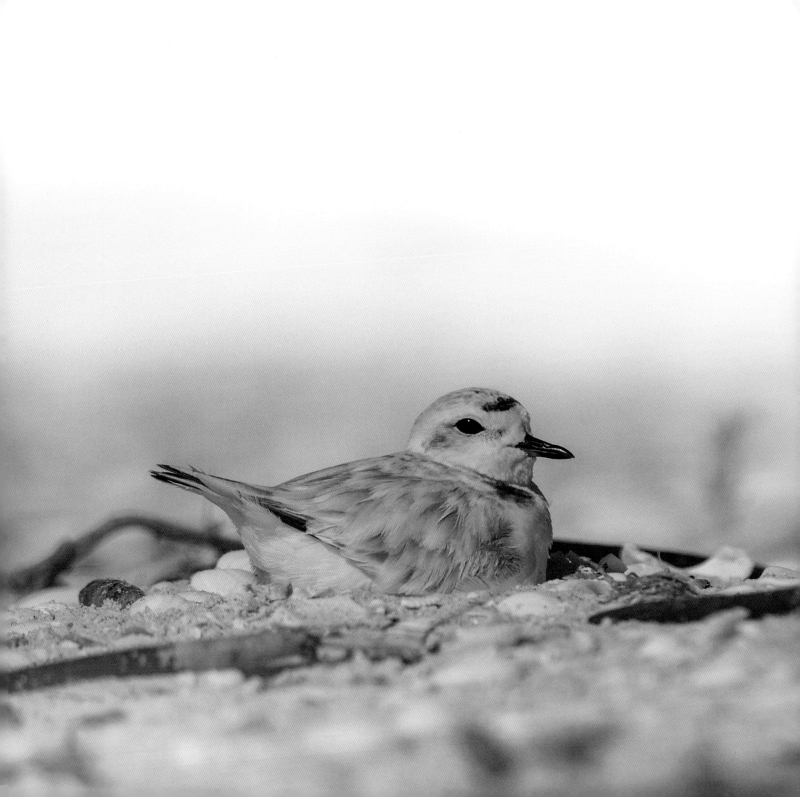

BEACH SAND CAMOUFLAGE The endangered Snowy Plover is a tiny, nearly pure white bird that makes its shallow nest in soft beach sand. The nest is located in the open, but due to the feather color, both bird and nest blend into the habitat, making them difficult to see even if you know where to look. The mother sits perfectly still on the nest for days to avoid attracting attention. Her coloring makes her look like one of the seashells strewn across the beach.

Snowy Plover

NOT JUST WATER BIRDS Some water birds, such as Long-billed Curlews and Willets, are also prairie birds. These large, long-billed birds look more like they should be at the beach, not landlocked in the middle of the country. Marbled Godwits are tall birds with impossibly long bills. They build shallow nests in the tallgrass prairies of Montana and North Dakota. When the nests are unattended, their olive green speckled eggs blend with the surroundings.

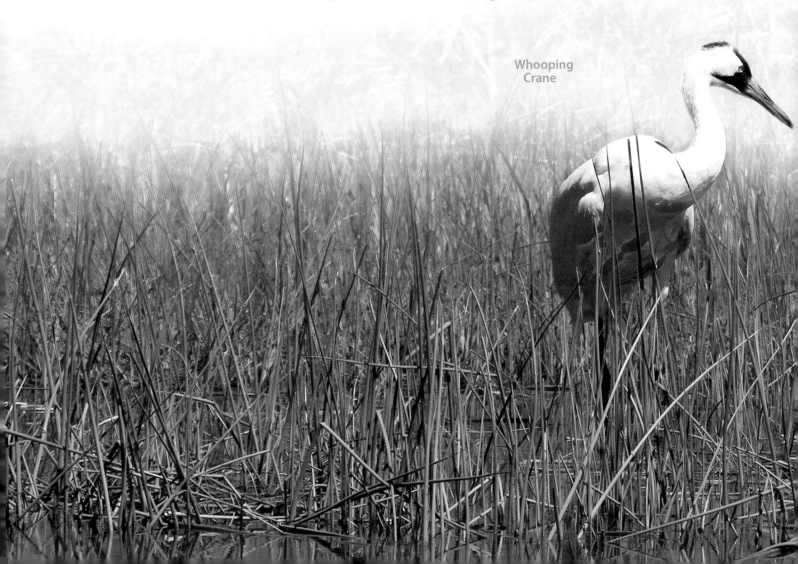

Whooping Crane

Whooping and Sandhill Cranes are upland water birds. Whoopers reach a height of almost 5 feet, while Sandhills are nearly 4 feet tall. Cranes build large mound nests in wetlands. They usually have two babies, which follow their parents around just hours after hatching and swim from the beginning. Towering over them, parents snap up insects and gently feed the kids.

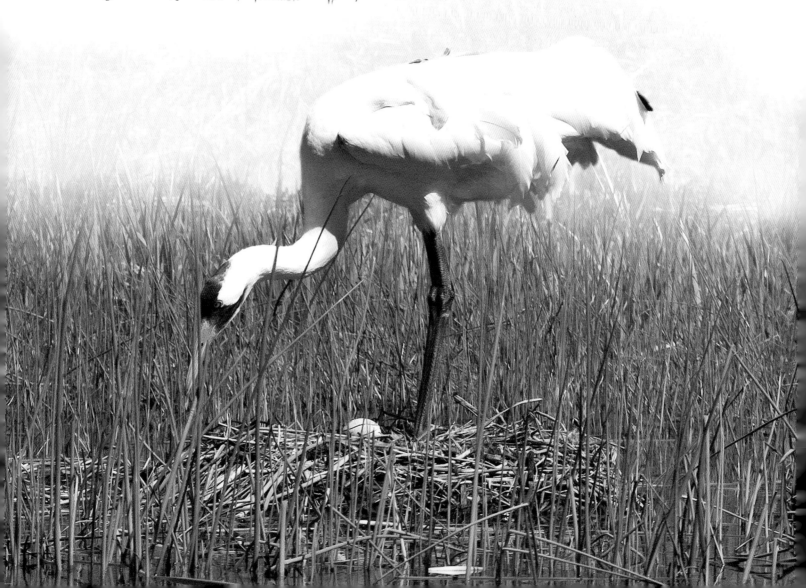

About the Author

Naturalist, wildlife photographer and writer Stan Tekiela is the author of the popular nature appreciation book series that includes *Cranes, Herons & Egrets*. He has authored more than 165 field guides, nature books, children's books, wildlife audio CDs, puzzles and playing cards, presenting many species of birds, mammals, reptiles, amphibians, trees, wildflowers and cacti in the United States.

With a Bachelor of Science degree in Natural History from the University of Minnesota and as an active professional naturalist for more than 25 years, Stan studies and photographs wildlife throughout the United States and Canada. He has received various national and regional awards for his books and photographs. Also a well-known columnist and radio personality, his syndicated column appears in more than 25 newspapers and his wildlife programs are broadcast on a number of Midwest radio stations. Stan can be followed on Facebook and Twitter. He can be contacted via www.naturesmart.com.

Great Horned
Owl

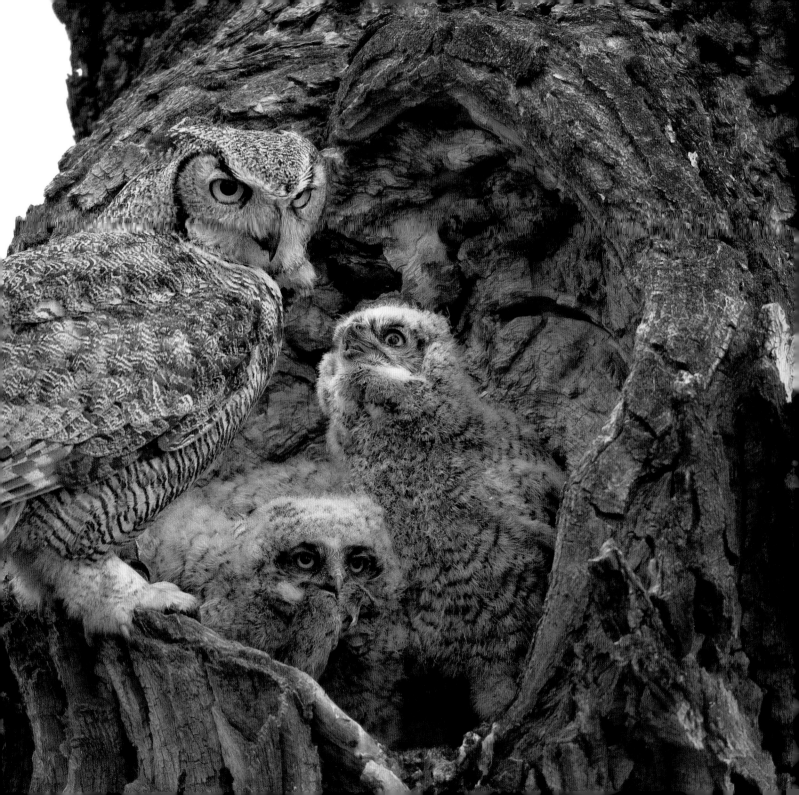

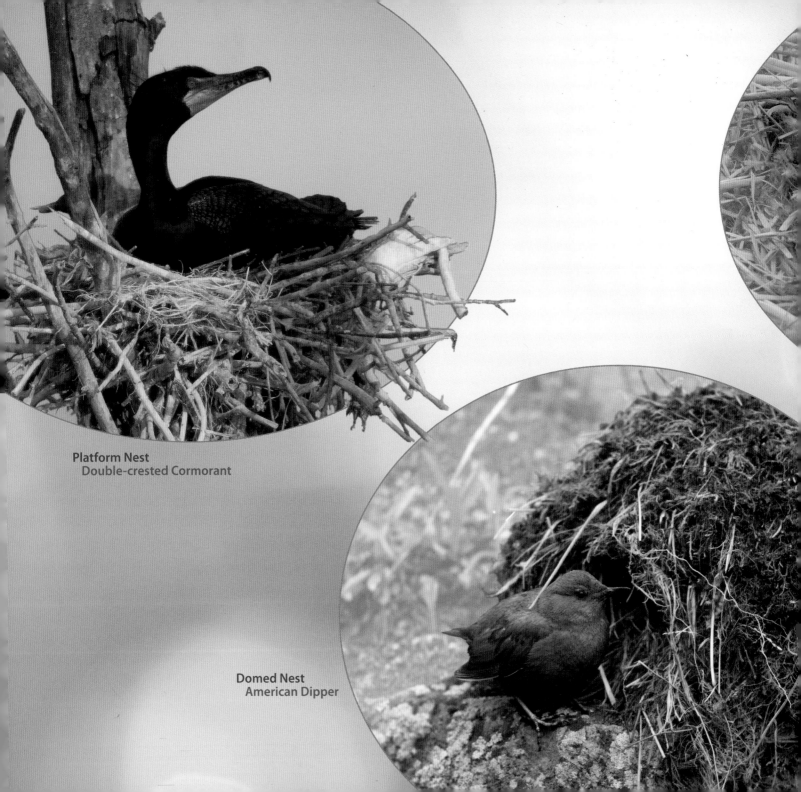

Platform Nest
Double-crested Cormorant

Domed Nest
American Dipper